D0770410

FROM MINIMAL TO CONCEPTUAL ART

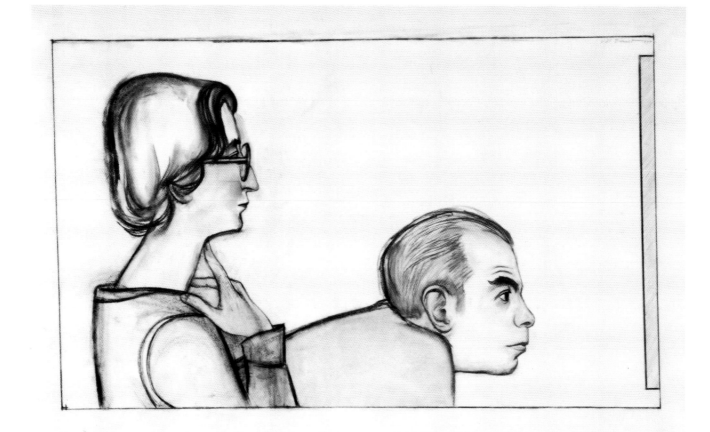

FROM MINIMAL TO CONCEPTUAL ART

Works from The Dorothy and Herbert Vogel Collection

Essay by John T. Paoletti
Interview by Ruth E. Fine

National Gallery of Art • Washington

From Minimal to Conceptual Art: Works from The Dorothy and Herbert Vogel Collection was organized by the National Gallery of Art, Washington. Curators, Mark Rosenthal and Ruth E. Fine; Curatorial assistant, Molly Donovan

Exhibition Dates:
National Gallery of Art, Washington
29 May–27 November 1994

This exhibition has been made possible in part by The Circle of the National Gallery of Art.

Library of Congress Cataloging-in-Publication Data
From minimal to conceptual art: works from the Dorothy and Herbert Vogel collection / essay by John T. Paoletti; interview by Ruth E. Fine.
 p. cm.
 Includes bibliographical references.
 ISBN 0-89468-206-7
 1. Minimal art—United States—Exhibitions. 2. Conceptual art—United States—Exhibitions. 3. Art. Modern—20th century—United States—Exhibitions. 4. Vogel, Dorothy—Art collections—Exhibitions. 5. Vogel, Herbert—Art collections—Exhibitions. 6. Art—Washington (D.C.)—Exhibitions. 7. National Gallery of Art (U.S.)—Exhibitions. I. Paoletti, John T. II. Fine, Ruth, 1941–. III. National Gallery of Art (U.S.)
N6512.5.M5F76 1994
709'.73'074753—dc20 94-11322
 CIP

Copyright © 1994 Board of Trustees, National Gallery of Art, Washington. All rights reserved. This book may not be reproduced, in whole or part, in any form (except in reviews for the public press and other copying permitted by Sections 107 and 108 of the U.S. Copyright Law) without written permission of the National Gallery of Art.

Produced by the editors office
Frances P. Smyth, editor-in-chief
Edited by Julie Warnement
Typeset in San Serif bold and Caslon by Artech Graphics II, Inc., Baltimore, and printed on Warren Lustro Enamel Dull by Schneidereith & Sons Printing, Baltimore

Note to the Reader

Dates for Artists Writings

Quotations are dated when the primary source was available.

Dimensions

Height precedes width, which precedes depth. Unless specified otherwise, dimensions are given in inches, followed by centimeters in parentheses.

page 144: cat. 89
frontispiece: Will Barnet, *The Collectors*, 1977, compressed charcoal and carbon on Casson paper, The Dorothy and Herbert Vogel Collection, Promised Gift of Dorothy and Herbert Vogel
page 54: Dorothy and Herbert Vogel in the 1992 exhibition *Dürer to Diebenkorn: Recent Acquisitions of Art on Paper* at the National Gallery of Art. They are shown with two works in the Vogel Collection: upper left, *Four Color Frame Painting #1* (1984) by Robert Mangold, and right, *Valley Curtain, Project for Rifle, Colorado* (1971) by Christo. Also shown, lower left, is *Mud Flow (F-14)* (1969) by Robert Smithson, Gift of Werner H. and Sarah-Ann Kramarsky, in Honor of the 50th Anniversary of the National Gallery of Art.

Photo Credits

fig. 4—photo by Geoffrey Clements, New York, collection credit: Collection of Whitney Museum of American Art. Gift of Mr. and Mrs. Eugene M. Schwartz and purchase, with funds from the John I. H. Baur Purchase Fund; the Charles and Anita Blatt Fund; Peter M. Brant; B. H. Friedman; the Gilman Foundation, Inc.; Susan Morse Hilles; The Lauder Foundation; Frances and Sydney Lewis; the Albert A. List Fund; Philip Morris Incorporated; Sandra Payson; Mr. and Mrs. Albrecht Saalfield; Mrs. Percy Uris; Warner Communications Inc. and the National Endowment for the Arts 75.22

CONTENTS

FOREWORD

Thanks to the generosity of Dorothy and Herbert Vogel, the National Gallery of Art has become home to an impressive group of works dating from the 1960s to the present. The renowned Vogel collection is unique among other collections in the field of contemporary art, both for the character and breadth of the objects and for the individuals who created it. Applying a modest amount of money, but an extraordinary degree of insight, persistence, and daring, the Vogels have assembled a vast resource with which the Gallery can exhibit many crucial developments in later twentieth-century art. For *From Minimal to Conceptual Art*, the first extensive exhibition of the Vogel collection at the Gallery, we have chosen to show highlights from the areas for which the collection is best known. In future years other glimpses into the collection will be seen.

The place of the Vogel collection at the National Gallery of Art is owed to the initiative and creativity of J. Carter Brown, director emeritus, and Jack Cowart, former curator of twentieth-century art. Working with the Vogels, they encouraged the development of the agreement by which this gift to the nation was made. Other staff who participated in this important achievement were Philip C. Jessup, Jr., and Nancy Breuer in the office of the secretary and general counsel.

The current exhibition has been organized by the team of Ruth E. Fine, curator of modern prints and drawings, and Mark Rosenthal, curator of twentieth-century art. Molly Donovan, curatorial assistant, has worked tirelessly on all aspects of the organization, and Professor John Paoletti has written an insightful introduction for the catalogue.

The Gallery is immensely grateful to Dorothy and Herbert Vogel for having made this extraordinarily rich resource available to the nation. Theirs is a great story and the National Gallery is pleased to participate in its telling.

Earl A. Powell III
Director

COLLECTORS' ACKNOWLEDGMENTS

Everyone at the National Gallery of Art who worked on our collection and this exhibition deserves our heartfelt thanks. Above all, we are grateful to Jack Cowart, former curator of twentieth-century art, whose idea and vision brought us to the Gallery in the first place; we are also grateful to J. Carter Brown, director emeritus, Earl A. Powell III, director, Alan Shestack, deputy director, and Roger Mandle, former deputy director, for their encouragement and support. Jane Gregory Rubin, our lawyer in New York, wrote the agreement and planned the transfer of our collection to the Gallery. The Gallery's Philip C. Jessup, Jr., secretary and general counsel, and Nancy Breuer also worked on the agreement. Mary Suzor and Anne Halpern registered the works of art, which were moved from our home to the Gallery with the assistance of Gary Webber. Staff in the twentieth-century art department, past and present, including Kimberly Bockhaus, Laura Freeland, Melissa Geisler, Linda Johnson, Sara Kuffler, Stephanie Leone, Marla Prather, Jeremy Strick, and Amy Mizrahi Zorn inventoried and researched the collection. Critical assistance was provided by the staff in the modern prints and drawings department, especially Carlotta Owens and Charlie Ritchie, and the conservators, including Julia Burke, Jay Krueger, Constance McCabe, Judy Ozone, Pia DeSantis Pell, Shelley Sturman, and Judy Walsh. Hugh Phibbs and Jenny Ritchie did the matting and framing, and Dean Beasom, Richard Carafelli, Philip Charles, Lorene Emerson, and Robert Grove photographed the collection. D. Dodge Thompson, chief of exhibition programs, and Kathleen McCleery did essential work to bring this exhibition together. The elegant party that celebrated our collection was organized by Genevra Higginson, assistant to the director for special events. Ruth Kaplan, press and public information officer, and Deborah Ziska made critical contributions, with assistance from Nancy Soscia. The installation was designed by Gaillard Ravenel, senior curator and chief of design, and William Bowser. Frances Smyth, editor-in-chief, Mary Yakush, and Julie Warnement produced and edited the

exhibition catalogue, which includes an insightful essay by John Paoletti and an interview by Ruth Fine. Lastly, Mark Rosenthal and Ruth Fine curated the show, and Molly Donovan worked on the exhibition from start to finish.

We would also like to thank all the artists in this exhibition and all the other artists whose works we have acquired. Without them, we would not have a collection.

Dorothy and Herbert Vogel

FROM MINIMAL TO CONCEPTUAL ART

THE FORM OF THOUGHT

John T. Paoletti

Your Lordship sends to tell me that I should paint and have no doubts. I answer that painting is done with the brain, not the hands; and one who cannot have his brains about him dishonors himself. . . .

Michelangelo, October 1542[1]

The art in the Vogel collection and the thought that lies behind much of it emerged from the crucible of conflict and social change of the late 1960s and the early 1970s. Just as political policies were radically challenged if not completely altered as a result of the upheavals of those years, so too were artistic practices that had placed American artists in the leadership of an ever expanding international community of artists.[2] A new group of artists radically altered their production, not merely to provide superficial novelties of style, but to question in a fundamental manner the entire practice of art making and the expanding systems of galleries, critics, and media attention that sustained it. Their fresh explorations of style and media were an outcome of significantly new and provocative thinking. They explored the very nature of the art object, how it functioned, and, more important, how it was allowed to function within a culture composed of overlapping and often contradictory systems of support. Seth Siegelaub, one of the central figures encouraging radical new explorations in the visual arts during this period, indicates that at least for the artists who grouped around the idea of conceptual art "there was an attitude of general distrust towards the object, seen as a necessary finalization of the art work, and consequently towards its physical existence and market value. There was also the underlying desire and attempt to avoid this commercialization of artistic production, a resistance nourished, for the most part, by the historic context: the Vietnam war and subsequent questioning of the American way of life."[3]

1

American artistic successes of the previous twenty years provided powerful models for the generation of artists coming into their own in the mid-sixties. They also produced equally powerful constraints, especially since the art itself, most notably abstract expressionism, was mediated by a strong, positivistic criti-

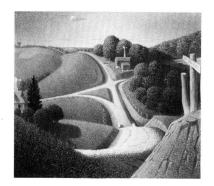

fig. 1. Grant Wood, *New Road*, 1939, canvas adhered to paperboard mounted on hardboard, 13 x 14⅞ in. National Gallery of Art, Washington, Gift of Mr. and Mrs. Irwin Strasburger

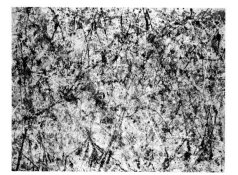

fig. 2. Jackson Pollock, *Number 1, 1950 (Lavender Mist)*, 1950, oil, enamel, and aluminum on canvas, 87 x 118 in. National Gallery of Art, Washington, Ailsa Mellon Bruce Fund

cal support system. The new art, therefore, responded not just to the style and content of immediately preceding work, but also to the deterministic critical language that had evolved to support and explain it. In some ways the young artists of the mid-sixties had no choice but to be critics and intellects themselves.

American art, its public, and the critical language needed to support it had developed at a quite remarkable pace after the Second World War. The crucial aspect of this development was its definitive move to abstraction by 1947 after considerable exploration of biomorphic and pictographic forms related to surrealism. That formal move also carried implications about content that placed the abstractionists in direct confrontation to the work of American regionalist painters like Thomas Hart Benton and Grant Wood (fig. 1), who had formed a definition of an official American art tied to a glorification of American values of the heartland. Abstraction also flew in the face of popular notions of art represented by the Norman Rockwell paintings that appeared so frequently on the covers of the *Saturday Evening Post*. Rockwell's vision provided a sharply delineated and sentimental ideal of the American family not too far removed from that of the regionalists. Jackson Pollock's first pour paintings were made in 1947 (fig. 2), Barnett Newman's first zip paintings in 1948 (fig. 3), and Mark Rothko's first floating rectangles of color in 1949. Although the works of these artists have now become classics of twentieth century art, it is important to recall that no critical language really existed to discuss abstraction or to explain it to the wider audience outside the community of artists responsible for making it. There was no way, that is, to counter *Life* magazine's all-too-clever and slyly malevolent characterization of Pollock's work as the product of "Jack-the-Dripper," a tactic of journalistic crowd-pleasing still prevalent in the public media. In fact, just as American art had seemed to remake itself through abstraction, the critical response also had to remake itself in order to make sense of these new developments.

Leading the intellectual discourse on abstract expressionism was the modernist criticism of Clement Greenberg, who expressed his own excitement about the new painting and his belief in what the artists were doing within a particular—and narrow—intellectual framework. Greenberg explained abstraction as a necessity determined by the fundamental properties of painting itself. At its irreducible core painting was, for Greenberg, merely a flat surface covered by pigment. Anything that weakened this flatness, such as illusionism or figuration, was to be excised. This left abstraction as the only acceptable form of painting. Flatness was to be achieved by defining the concept of all-over painting, that is painting that pushed towards the edges of the canvas, that was evenly disposed

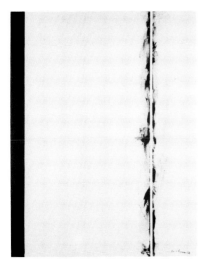

fig. 3. Barnett Newman, *First Station*, 1958, magna on canvas, 77¾ x 60½ in. National Gallery of Art, Washington, Robert and Jane Meyerhoff Collection

over the surface, and that did not define any particular area of the canvas as privileged over any other. A happy corollary of such an interpretation is that it gave a quasi-scientific measure for describing what was good painting and what was bad painting. The issue of quality was a dilemma for abstraction that was not faced in quite the same way in illusionistic painting; the more a painting responded to the all-over look defined by Greenberg the better it was.

Greenberg supported his position with selective references to history. Looking back over the art of the previous century he traced, beginning with Edouard Manet and continuing through the cubists and Henri Matisse, a successive flattening out of the picture space, a pressure towards surface that reached its conclusion in the works of American abstractionists. History, treated in the same linear fashion that Vasari had used four hundred years earlier in his *Lives of the Famous Artists* (1550, 1568), became both the model and the justification for abstraction, the art of the modern world. Content, of course, did not enter this critical framework even though Pollock had made several references to landscape in his interviews. And, Rothko and Newman had been quite explicit about tragedy and the spiritual as essential components of their work. Serious discussion by critics of content in the work of the abstract expressionists did not occur until Thomas Hess' catalogue essay for a retrospective of Barnett Newman's paintings in 1971, perhaps another manifestation of the radical rethinking of the arts at that time.[4]

Other interpretations of abstract expressionism also evolved, although they did not have quite the same staying power and effect on successive generations of artists as Greenberg's modernist criticism. Harold Rosenberg talked about the painting of artists like Pollock and Willem de Kooning, the gestural abstractionists, as action painting, the sheer, raw record of artistic activity on the surface of the canvas. Such an interpretation fueled the discussion of painting as manifestations of particular personalities. The artist could become a cultural hero as *Life* suggested in 1951 when it published an article with the title "Jackson Pollock: Is He the Greatest Living Painter in the United States?"[5] This article was simultaneously a curious manifestation of the "great man" approach to history and art history, and a prescient preview of the modern voyeuristic fascination with artists' lives that Andy Warhol was to capitalize on several years later.

Perhaps more important than any of these concerns, however, was the discussion of abstraction as the first manifestation of a truly American art that not only did not mirror European predecessors but equaled them in historical importance. It seemed very important to some—although not to the artists— that the painting be seen in that nationalistic light, as a unique display of

15

American creativity that subsequently provided the material for exhibitions abroad organized by the United States Information Agency (USIA).[6] The point was hardly subtle and barely disguised: just as the United States led the postwar world in economic and military power it had also taken control of the avant-garde and led the world in artistic exploration. Ironically at the same time that the government was using the accomplishments of the abstract expressionists as symbols of American power and success, these very same artists were being denounced by George Dondero (R-Michigan) in the United States Congress. Dondero saw them as Communists because of their leftist political associations, and their art as anti-American, because of its European roots. True American art for Dondero was that of painters like Grant Wood.[7] Although the attempt to censor the art of the abstract expressionists was ultimately not successful, it did indicate—and does still—that art can be both political and politicized, regardless of the wishes of the artists.[8]

No sooner had abstract painters like Pollock, de Kooning, Franz Kline, Newman, and Rothko begun to receive critical attention than they faced challenges to both their painterly manner and their subject matter from within the artistic community. In the early 1950s Robert Rauschenberg and Jasper Johns had begun to suggest alternative modes of artistic practice. As early as 1951 Rauschenberg challenged the colorism and painterly application of the abstractionists by his three- and seven-panel white paintings. Their flatly painted, uninterrupted surfaces were totally blank, a removal of both the art and the content that seemed central to the understanding and acceptance of the abstract expressionists. In 1953 Rauschenberg erased a de Kooning drawing that he had persuaded the artist to give him. This startling gesture of eradicating the father figure gave pointed recognition to the power that the abstract expressionists exerted over the younger members of the artistic community. Like the white paintings, the erased drawing also cleared the slate so that Rauschenberg and others might start afresh. By 1955 Rauschenberg blurred the boundaries between painting and sculpture with his "combines." These jerry-built three-dimensional paintings integrated found objects and images of the popular media into the work. The combines challenged the hegemony of painting and the sacredness of the carefully finished masterwork that then dominated American artistic practice and critical attention. They also challenged the high-minded discussions of the spiritual that governed discourse of Rothko's and Newman's painting. Paradoxically, however, Rauschenberg's expressionistic treatment of pigment throughout the fifties retained characteristics comparable to de Kooning's. Thus, his alteration of the

fig. 4. Frank Stella, *Die Fahne Hoch*, 1959, black enamel on canvas, 121½ x 73 in. Collection of Whitney Museum of American Art, New York

painting's support and his acceptance of banal, popular subject matter only partially transformed the style of the abstract expressionists, although it obviously played havoc with any modernist critical approach to painting.

Johns responded to the critical discussions surrounding the fundamentally American character of abstract expressionism—and the political discussions of it as un-American—by painting his first *Flag* in 1955. Painterly it was, with all the lusciousness and texture of any abstract gestural painting. But it was also a familiar icon, an insistent—and popular—image that argued against modernist critics' insistence that abstraction was not only the hallmark of new American painting, but the very condition of contemporary painting itself. *Flag* operated on a number of fronts simultaneously. It clearly adhered to modern critical demands for a flat, all-over painting, extending to the very edges of the frame. Yet it was obsessively an image, one that referenced itself out of the picture. It was very painterly, with all of the hand marks of individual artistic creation, yet its form had already been predetermined, and so owed nothing to the artist who "merely" selected it. And if one of the issues was the making of an American art, what could be more American than the American flag? Yet Johns carefully titled the painting *Flag*, as if wishing to distance himself from a trivial political agenda, while at the same time realizing that "American Flag" would have been a verbal/visual redundancy.

17

In *Die Fahne Hoch*, 1959, (fig. 4) Frank Stella painted his own flag and his own monochrome painting. Consisting of thick black bands of oil paint that repeat the shape of the canvas, thus emphasizing its flatness, the painting provides a logical extension of the modernist critical paradigm and a rejection of the novelties of Rauschenberg and Johns. The black pigment, as restrictive as the geometrical shapes that it describes, asserts itself like a manifesto on the painting. In this radical reduction, paint becomes a linear, contained graphic gesture. Stella quite literally painted inside the penciled lines that he had first drawn on the surface of the raw canvas. *Die Fahne Hoch* and other black paintings of 1959 defined a system using the exterior shape of the painting and its central horizontal and vertical axes, and repeated similar units within the system until there was no room left on the canvas. Yet the rectangular shapes of *Die Fahne Hoch* also break down into four trapezoids on the surface of the painting; the painting is not quite as simple as it first appears. Its geometric system and visually apparent logic were parallel to certain of Johns' paintings of this date, but by their abstraction argued for the continued possibilities of modernist painting.

By 1962 when Pop art first appeared in New York galleries, another voice had been added to the alternatives facing artists, this one even brasher

than Rauschenberg and more commercial in its selection of cultural icons than Johns. Its obsessive imagery was a frontal attack on the entire modernist system, particularly as it confused the boundaries between elite art and popular art, and used the same strategies as advertising to convey its images. Warhol even used the silkscreen technique so that multiple images could be made from photographic reproductions. The painting surface with its flattened, dulled quality of the cartoon and newspaper illustration disguised the artist's hand quite as definitely as Stella's geometric abstractions and resisted any reading of illusionistic space behind the surface. Pop was instantaneously successful, welcomed by a new audience that was the product of the same postwar economic boom and media hype that Pop images celebrated. But the cultural objects that they *re*-presented, like Warhol's soup can, were decontextualized as details from a culture enlarged for scrutiny, despite their apparent triviality, and thus starkly objectified.

2

An interesting thing to start with would be the whole notion of the object, which I consider to be a mental problem rather than a physical reality.

Robert Smithson, 1969[9]

The real energy in art is mental energy. But it is not intellect. Emotion propelled by mind is the dynamic force.

Mel Bochner, 1988[10]

One of the jobs of the artist is criticism. It's one of the most noble parts of the artist's work.

Richard Tuttle, 1993[11]

What, then, were the artistic responses possible within this intense artistic environment that had emerged with all of its contradictory successes in New York in the twenty years after World War II? One was to continue the attempt to define the art object more precisely, to continue, that is, the process of definition begun by the modernist critics. Such considerations ultimately moved significant artistic activity into sculpture, always a stepchild in modernist writing. Paradoxically, however, concentrating on the object led to the conclusion that the work of art was but one part of the total experience of perception. Art-for-art's sake, then, became a critical fiction, indeed a logical impossibility.

When traditional elements such as figuration and narrative are eliminated, only the bare painted surface or a hard geometrical structure in three dimensions remains, as typified by many artists in the Vogel collection. The structural order then becomes a central focus since it is not possible to fall back on recounting a narrative, a response that turns any visual object into a literary one. Even the most restrictive or minimal activity on a reduced painted surface responds to the overall shape of the surface, outlining, as it were, the determinants of the composition given to the artist facing the blank canvas. Art historical study had traditionally used analysis of color, composition, even brushwork as routes to understanding painting from earlier historical periods. Eccentrically shaped paintings, such as arched altarpieces or complicated ceiling paintings, only emphasized the need to pinpoint controlling elements within the composition and to attempt to reconstruct the artist's cognitive process in determining the placement of figures within some kind of imposed structural order.

In their most reduced form the painting and sculpture of the past thirty years present the structure, and sometimes all its variations, with as much clarity as possible. The simplicity of the forms is a disguise for the complexity of thought that gave them definition. The very process of thought and composition, the activity of thinking divorced from the signs of making, become the content of the work. Sometimes, as in the work of Carl Andre, Richard Nonas, and Robert Mangold, the forms are quite simple and direct: short declarative sentences that bring viewers to the heart of the issue of defining the object. In such cases chance is apparently removed. Sometimes, as in the work of Mel Bochner, Hanne Darboven, Eva Hesse, and Sol LeWitt, the forms are quite complex: long deductive or syllogistic developments that allow viewers to pursue an idea with all of its possibilities. Thinking is represented and contained by the forms within the object itself; it is referenced only in a superficial way to the world outside the object, as for example the white architectural forms of LeWitt's cubes were to their stripped, white, rectilinear exhibition spaces.

I painted until about 1961, at which time I decided that my works had become so visually reductive that little distinction existed between the image within the edges of the canvas and that outside it. As the painting has become an "object," I went "off the wall" and began making constructions, which soon became associated with such terms as "Minimalism" and "Primary Structures." Such designations did not exactly apply because I was more interested in making forms that expressed extensiveness rather than interiority.

Douglas Huebler, 1980[12]

cat. 78

20

cat. 21

Recently there has been much written about minimal art, but I have not discovered anyone who admits to doing this kind of thing. . . . Therefore I conclude that it is part of a secret language that art critics use when communicating with each other through the medium of art magazines. . . . It must refer to small works of art.

Sol LeWitt, 1967[13]

The field of the history of art is strewn with terms or labels that seem to pop up out of critical responses like mushrooms; they are designed to encapsulate in a shorthand manner the primary characteristics of the art being described. Some of these, like Gothic and baroque, were originally pejorative terms, meant simultaneously to describe and to criticize in a rather blunt, negative fashion. Others, like minimal and conceptual, pervasive in the recent literature of artistic criticism, were coined in an attempt to find a term that was positively descriptive. Early critics supportive of the turn to reductivist physical properties in the art of the early sixties used minimal to describe their formal elements, although there were others who deliberately suggested that a minimalist object led to minimal artistic quality and minimal interest. Use of the term conceptual removed consideration from the object to the mental processes of the artist. It reclaimed the artist's role in the process of creation *before* the object took shape. At the same time, it also focused on the content of the work and how a viewer might perceive that content. Unfortunately any descriptive word, as LeWitt implied in a tongue-in-cheek manner, collapses too many possibilities into a single term and leads to possible misunderstanding. There is nothing minimal about what has come to be called minimal art, either in its reductivist formal components or in the nature of its artistic concerns.

Robert Ryman began to limit his palette to white in the late fifties and has not changed it since. Each of his works (cats. 77, 78) is an extended meditation on surface, brushstroke, or light—root concerns of the painter—without the complications of color relations. Although earlier artists had limited their colors to the three primaries, like Piet Mondrian, or to black and white, like Kasimir Malevich, as a way of simplifying their paintings towards some universal message, Ryman chose to work with light in its purest painterly form. Moreover, his paintings tend to be unified wholes with no discernible divisible units suggested within them except for framing elements at the edges. Each painting is a variation on a constant theme, just as Greek Doric temples repeat their formal elements from building to building while remaining distinctive as individual structures.[14] James Bishop (cats. 21, 22) also concentrated on the painterly surface, meticulously creating a tonal haze

cat. 59

that veils the precise grid structuring the overall painting into a unitary form. The barely visible geometry serves to maintain attention on the surface while at the same time space, created by color, weaves through the lattice. The vagaries of the artist's hand and of paint application, so noticeable in Ryman's early work, are subordinated to the interaction of diaphanous color and ordering grid.

Brice Marden's rich, monochromatic surfaces of wax and oil heighten the shimmering quality of light that seems both to flutter above the surface of the painting and also to be trapped in the wax (cats. 59, 60). Marden painstakingly built up his surfaces so that they have a dense opacity, despite the light; and he carefully smoothed them so that any mark of creation is all but invisible. However, he, like Jasper Johns, sometimes left the canvas blank at a thin edge along the bottom in order to catch the dribbling residue of the invisible activity responsible for the painting above. Jo Baer repressed all of the painterly qualities retained in the surface by Ryman and Marden in her flat white canvases with black "frames" (cat. 10). Black and white are opposed in the paintings, as are center and edge. No compositional or coloristic irregularities exist that would indicate any movement or divert attention from the absolute zero of the picture plane representing only itself. Although Ryman, Marden, and Baer might each be considered to have taken an extremist position, their concentration on the surface of the painting demonstrates the rich variety of possibilities that can occur on a limited field with a tightly restricted program.[15]

Robert Mangold, on the other hand, inserts a calm but decisive rationality into his paintings by imposing crisp geometric lines onto their flat, soft-color surfaces (cat. 55). The eccentric shapes of Mangold's paintings assert their object status, especially when they are constructed of multiple units minimally but clearly separated from one another by shadowed space masquerading as line. Their color and the glinting graphic line maintain their status as paintings. Mangold creates a tension between the drawn line and the shape of the canvas, as if line and support depended upon one another for existence, as indeed they do. In *Red/Green X Within X* (cat. 56), Mangold seems to give a precise description of his painting. The colors of the panels are indeed red and green, although there are two quite distinctive greens, and a penciled X is placed on the constructed X of the colored panels. Yet the painting is much more complex than that simple description indicates, perhaps it is even contradictory if one considers what "within" might mean here and how surface planes can be "within" a line. On the red arm of the painted X, the drawn line bisecting it goes from one end of the arm to the other, there-

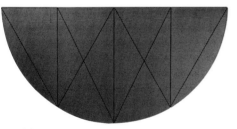

cat. 55

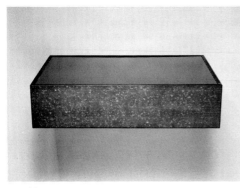

cat. 44

fore appearing coincidental with the surface of the painted panel. On the other arm, the drawn line—remaining well within the extremities of the frame—crosses three separate panels, helping to lock them into a unified composition. Yet it is virtually impossible to read the red arm of the painted cross as being anywhere but on top of the other arm, even though the widths of the green arm are different. None of the arms of the drawn X are the same length. And, their crossing point at the heart of the composition does not mark the center point of the arms of the painted cross. A simple system yields complex results and produces a visual challenge for the viewer to assess both the measures of and the relations between the reduced individual units.[16]

The virtually exclusive focus of modernist criticism on painting has proved to be one of its severest limitations. But the issues that it raised concerning the defining elements of painting could be applied to sculpture: What properties belong uniquely to sculpture or what are its basic, defining elements? Such questions would lead to considerations of volume, mass, weight, three-dimensionality, and the occupation of space. They would eliminate illusionism and figural form, extension or any other anthropomorphic attributes. Andre's *Nine Steel Rectangles* (cat. 4), one of his floor pieces, is an essay in this investigation, as are LeWitt's *Floor Structure Black* (cat. 49) and Donald Judd's untitled galvanized iron box (cat. 44). These works share two formal qualities that characterize what came to be known as minimalism: a restricted, geometric vocabulary and a machined form, often commercially manufactured. Moreover they are referenced to nothing but themselves. The reduction of form to squares and rectangles fixes it as a stable one, free of any movement outside the unitary block that would be suggested by eccentric angles or protruding units. The square is an irreducible unit and has been seen in both ancient Roman and in Renaissance artistic theory as a symbol of perfection, a concept of the ideal that permeates minimalist work. The anonymous surfaces of the sculpture, whether in the rough cast state of the Andre or in the highly polished manufactured form of the Judd, essentially remove the issue of the artist's manual activity from any discussion of the work. Such surfaces allow for a single-minded focus on their sculptural properties rather than on the personal idiosyncrasies of the artist and his craft. The art object becomes truly an object, existing in our space in a way that painting can never quite do. Critical discussions of the nature of painting had ironically provided the basis for a renaissance of sculpture, always a secondary art in America. But in both painting and sculpture, minimalism, related to the formal properties of the object, can be seen both as a critique and as a final step of modernism.

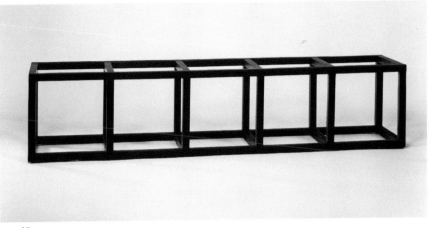

cat. 49

Nine Steel Rectangles is so thin that it is barely distinguishable from the floor on which it is placed. Each of the nine units is the same size. The implication of this repetition is that the work could be considerably bigger, had Andre provided enough of the individual units or had the space where it was to be sited demanded a larger scale. Its outer boundaries maintain the unitary format of each of the multiple tiles contained in the whole. Through repetition the multiple units emphasize the dimensions of length and width, contrasting with the barely perceptible third dimension provided by the thickness of the tiles. Andre seems to be asking about the limits of dimension, about how much to reduce the third dimension before the sculpture becomes a drawing. As minimal and compressed to the floor as the forms of *Nine Steel Rectangles* are, they assert a definite conception of mass—Andre uses dense metals—and spatial boundaries. Andre described his work as "existing as real material conditions in the world" and not as "the embodiments of ideas or conceptions."[17] There is clearly a space that reads as sculpture and a surrounding space that reads as room; this is felt particularly acutely when a museum visitor inadvertently discovers that he or she is standing on one of Andre's floor pieces and, contrary to all museum policy, is touching, if not trampling on, a work of art. The individual units are kept loose, so that each time the work is shown the pieces are recombined in different ways, thus suggesting that no relational connections can be made between the units, that no unit is privileged over another, and that the object, as object, is not precious. Its message emphasizes the relationships of object and space, or more simply, the very nature of sculpture.[18]

Floor Structure Black by LeWitt also extends across the floor, although its height and width are modest. The sculpture is skeletal, although what is there is painted black and appears to be dense and implacable. The work has an

23

internal volume, outlined by its black form, but inside and outside are permeable concepts since the sides are completely open. Thus, as precise as the geometrical form appears to be, it lacks discrete boundaries, unlike *Nine Steel Rectangles*, and it seems to have no mass despite its three-dimensionality. Like the Andre floor piece, LeWitt's structure rests directly on the floor, refusing the pedestal that would separate it from the viewers' space and valorize it as a work of art; it resolutely remains an object that demands consideration of its inherent properties, without regard for all of the predispositions—such as emotion—that are normally superimposed upon the work of art. Robert Grosvenor's drawing of a cross section of an I-beam (cat. 41), the material for sculpture, suggests the same concentrated awareness of length, width, and enclosed and open space, with the addition of spatial relationships and differences of mass.

Judd's box bounds space in a way that LeWitt's *Floor Structure Black* does not, but it also complicates the perception of that space by including the reflective surface of the Plexiglass. Although the exterior of the box has clear finite boundaries, the mirroring Plexiglass confuses the limits of the internal space and also visually denies the deliberate surface and mass of the outside shape. The inside and the outside of the object provide different perceptions of mass, of boundary, and even of dimension, despite the geometric simplicity of the form. What is contained suggests not boundary, but limitlessness. Cantilevered from the wall the box also raises the issue of weight and gravity through its metallic exterior surfaces. Yet a view of the interior makes the box seem weightless, contrary to the initial experience of the exterior. The reductive form in this piece, as in the others, provides a wide range of responses. Each response deals with how sculptural objects function and convey through formal properties the nature of their being.[19] Given the complexities of the visual process that such objects engender, "minimal" hardly seems an appropriate descriptive term either for the works or for the responses to them.[20]

3

There are moments when the self-consciousness of such an artistic constructional system becomes an engine that drives the art, as, for example, when the artist both adheres to the concept of the discreteness of the object as a work of art and at the same time calls attention to its illusionistic possibilities while simultaneously questioning them. At other times the appropriate response to the mental rigor of reductionism is simply to investigate its opposite.

The fictive tapes in Sylvia Plimack Mangold's paintings and the empty spaces between the individual units of Jennifer Bartlett's paintings each

call attention to the flatness of the picture surface despite any illusionism that the artists have constructed within. Each of these artists works with traditional subject matter—in the case of Sylvia Mangold's paintings (cats. 57, 58) and Bartlett's drawing (cat. 14), landscape—and yet each insists on foregrounding the artifice of the object so that the subject of the works is as much the painting itself as the landscape that may appear within it. In Mangold's untitled painting of 1979 (cat. 58), the successive frames of painted tape recall in a ragged manner Stella's *Die Fahne Hoch*. In this case, however, instead of referring to a critical system, the tapes and what lies within them record the process of one, fictive, sheet laid on top of another and painted, so that the brushwork spills out onto the, fictive, tape. Individual hand craft is very much a part of the message in Mangold's painting, unlike the machined surfaces of minimalist sculpture. It provides an illusionism that plays the tapes against the painting lying within their boundaries. What viewers look at, after all, is not the painting, but the frame, not what is inside the frame, but how Mangold—and viewers—frame what they see and define it as art.[21] This framing process is also very much a part of Chuck Close's reworked photograph, *Study for Keith* (cat. 32), which he used as a preparatory drawing for one of his large paintings.[22] In Bartlett's drawing (cat. 14), like her paintings, she plays a naturalistic rendering of the landscape against a geometric treatment of houses, described almost as flat toy blocks. The different modes of representing objects and the repeated tilelike units of the picture both describe a landscape and call attention to the process of creating and of viewing.[23] Each of these three artists underscores the power of their abstractions by working within realist conventions. In some ways, they have the best of both possible worlds.

The richness of a severely restricted formal language carries a powerful internal critique of the object, of how it functions, and of the limits of its meaning. Purity of form can carry with it an implied moral imperative. In order to avoid this dilemma, a number of artists developed a formal language that opposed the simplified forms of minimalism. Richard Artschwager's boxes (cats. 8, 9) made of rubberized horsehair are cases in point. They were a deliberate departure from the solid, crisp geometries of his formica-clad tables and chairs that, although referenced to recognizable ordinary objects, clearly transformed them into monolithic presences similar to the nonobjective forms of Andre or Robert Morris. The boxes retain a simple geometric shape, but their hardness is compromised by the wooly quality of the hair. Consequently, the immutability of their fundamental shapes is altered beyond recovery. Whereas minimal sculpture strives for a logic free of naturalistic references, the boxes

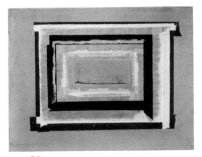

cat. 58

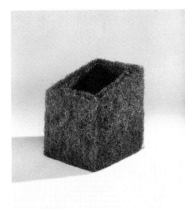

cat. 9

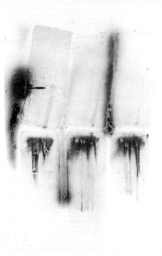

cat. 17

imply an organic movement out of control. The emotion-free minimal form has been transformed into a surrealist prod to weird, tactile sensibilities.[24]

Lynda Benglis' untitled beeswax plank of 1971 (cat. 18) is referenced in part to her fascination with Newman's ragged zips and his extremely thin paintings that, essentially, are zips isolated from the color field. It also derives from a minimalist aesthetic that she had already used in earlier work. Her untitled wax painting on paper of 1967 (cat. 17), for instance, isolates and objectifies the gestural stroke of the artist and is itself a reference to the painting of Kline. In the 1971 work, Benglis took an acetylene torch to a carefully layered wax surface. This caused it to melt and fuse in new expressionist configurations that accept their accidental merging and formation in much the same way that Pollock's skeins and puddles of pigment do. Here, as in her later polyurethane foam pours, painting becomes sculpture. Nothing could be further from the cool, detached, and anonymous forms of minimalist painting and sculpture. Moreover, the tactile, eroticized, and decorative forms and colors that Benglis used comment on critical expectations of "women's art," quite distinct from the machismo of certain hard-edged and massive forms of minimalist sculpture.[25]

Alan Saret pushed the accidental to apparent chaos with his wire pieces (cat. 79) that in some ways can also be thought of as three-dimensional analogues to Pollock's skeined pigment. The fragility of these drawings in air and the undefinable—because unreadable—movement of their line place them as far as possible from the solid, hard, phenomenologically precise surfaces of sculpture by artists like Andre and LeWitt.

The accidental can be structured to provoke consideration of the artist's action, which, since Pollock, had become a foreground issue with the evolution of action painting as a critical concept. The direct concentration on the self-conscious action of the artist can be seen in the repetitions of form in Hesse's 1967 grid drawing of small Xs repeated systematically within a predetermined grid of graph paper until the allotted space was filled (cat. 42). Unlike the fabricated sculpture of LeWitt, this intensely hand-drawn work reveals all of the idiosyncratic pressures of the artist's pen, leaving a varying textured surface on the sheet. It accepts the issue of accident as a record of activity, in some of the same ways that Benglis' torching of her wax also left a definitive mark of her presence in the work. The primal nature of Hesse's X and its repetitiveness suggest an artist placing her mark in an art that she is learning as if for the first time.[26] Edda Renouf also works within a carefully structured system, only to soften its boundaries even as she responds to its order. Either by pulling threads in the canvases of her paintings or by incising the paper of her drawings, she

creates a very low relief pattern on her surfaces over which she applies paint or chalk (cats. 70–72). Thus the pattern as it finally appears on the painting or drawing is not created by a carefully drawn line. Rather it is the result of the resistance of the evenly applied paint or chalk to the raised surface.

Darboven leaves a mainly illegible track of her activity, spread out under boxes labeled with specific days of the week, like a calendar, on the sheet marked with a specific date. Her cryptograms (cat. 34), used since 1968, mark time from one year to the next, from 31 [last day of] + 12 [December] + 7 + 4 [1974] = 54 to 31 + 12 + 7 + 5 = 55. The obsessiveness of the writing, framed within the restrictive order of calendar numbers, reads as an assertion of existence over time, an intensely personal energy in conflict with a superimposed order. It is telling that the artists most poignantly questioning a monolithic artistic structural system were women. Each asserted the individual gesture within the confines of a restrictive geometrical or temporal system.

4

When an artist uses a conceptual form of art, it means that all of the planning and decisions are made beforehand and the execution is a perfunctory affair. The idea becomes a machine that makes the art. . . . There is no reason to suppose, however, that the conceptual artist is out to bore the viewer. It is only the expectation of an emotional kick, to which one conditioned to expressionist art is accustomed, that would deter the viewer from perceiving this art. . . .

I do not advocate a conceptual form of art for all artists. I have found that it has worked well for me while other ways have not. It is one way of making art; other ways suit other artists.

Sol LeWitt, 1967[27]

For a variety of reasons I do not like the term "conceptual art."

Mel Bochner, 1970[28]

I followed the idea as far as I could, because it never was about making objects. It was always about making art, or doing art, really.

Robert Barry, 1986[29]

Though varied, the responses of artists like Judd and Benglis, Andre and Saret all focus on the morphological properties of the object as the incentive to the viewer's response. The physical properties of the art are the sole conveyors of information. In its most reductive form, this information provokes

another question about the object. If the anonymous look of works by Judd (cats. 44, 45), for example, drains the visual presence of the artist's action from the sculpture—as it literally does through its commercial fabrication—then where is the site of the artist's activity? LeWitt and others responded to this question by utilizing a formal system that defined the work of art before its inception. This strategy definitively moved consideration from the object to the mind of the artist, or perhaps more accurately privileged the idea of the object over the object itself. In 1967 LeWitt published what was to become one of the critical documents in the history of modern art. His "Paragraphs on Conceptual Art" provided, for better or worse, a name for what he and certain other artists were doing. LeWitt also provided both a reasoned explanation of such work and a caveat that conceptual art was but one way to pursue artistic activity, a warning that anyone viewing the Vogel collection will undoubtedly understand.[30] "Paragraphs on Conceptual Art" and "Sentences on Conceptual Art,"[31] published two years later, marked a watershed moment in the history of art by helping to frame all future discussion of artistic activity. They describe the genesis of a certain type of art in the United States and Europe, its intentions and meanings, and the cultural situation in which they were written and against which they were responding.

LeWitt addressed one of the fundamental issues in the viewer's ability to see the work of art clearly, namely preconceptions. His "expectation of an emotional kick . . . that would deter the viewer from perceiving this art" may be a reference to abstract expressionism or even to Pop, but the crucial concept of the passage resides in the idea of expectation, not in its particular source. The visual arts have an extraordinarily rich history, only a very small part of which a viewer can be aware of at any particular moment. But through that fragmentary experience—whether it is of something as direct as Leonardo da Vinci's ability to suggest mysterious messages of personality while depicting the facts of Mona Lisa's appearance or Claude Monet's ability to capture the shimmering and changeable effects of light in the landscape—viewers construct some category of activity and perception that is called art. Such constructions may or may not have anything to do with the objects that a viewer subsequently sees, especially in exhibitions such as this one that serve to transform or expand the very expectations that LeWitt critiqued. There is, after all, nothing inherent in any object that necessarily classes it as art. Individual viewers over time form the category of art, not the objects. And they expect some sort of return, what LeWitt, in a loaded phrase, called an "emotional kick."[32]

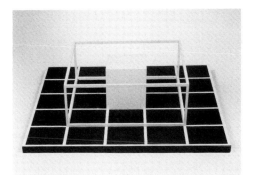

cat. 50

LeWitt's—and others'—strategy of concentrating on the idea of the work rather than on its physical form, on its conception rather than viewers' perceptions, describes a liberating feature of the situation for the arts in the mid-sixties. To be sure, LeWitt presented an extreme formulation, but at the time a polemical stance was necessary in order to bring home what should have been obvious, namely that art can satisfy the mind as well as the emotions. He makes the distinction between conception and perception perhaps too exclusively, one being "pre-, the other postfact," but it is a way of placing the mind of the artist in a preeminent position, a strategy that would have pleased Michelangelo. Ever since the Renaissance the artist's role within the culture has been dogged by a critical presumption that craft, aesthetics for some, is the measure of quality. LeWitt's position when he says that "what the work of art looks like isn't too important" is polemical, of course, a position taken to keep the discussion centered on the concept, for "conceptual art is made to engage the mind of the viewer rather than his eyes or emotions." His own work, after all, has always been meticulously made.

In "Sentences," LeWitt pursued this idea further by maintaining that "[o]nce the idea of the piece is established in the artist's mind . . . the process is carried out blindly. The process is mechanical and should not be tampered with. It should run its course." Thus his *Serial Project No. 1 B5* (cat. 50) of 1969 presents variations on the idea of the grid, two-dimensional, three-dimensional, open, and solid. Defining the system predetermines the composition and avoids idiosyncratic choices although it does not eliminate the possibility of chance. The content of the work is its idea. The same can be said of LeWitt's wall drawings (cats. 51, 52). Once described—*Lines, not straight, not touching, drawn at random, uniformly dispersed with maximum density covering the entire surface of the wall,*[33] for example—they define the work. But as precise as the titles are, they are merely descriptions and not directions; moreover they are open-ended. As in *Wall Drawing No. 26. A one-inch (2.5 cm) grid covering a 36" (90 cm) square. Within each one-inch (2.5 cm) square, there is a line in one of the four directions* (cat. 51), internal relational properties are left to the accident of choice by the individual draftsperson. LeWitt's wall drawings, like those of Robert Barry (cat. 13A), Lawrence Weiner (cat. 89), and others, exist as ideas, articulated in verbal form. Once the idea exists the work of art exists, whether or not it is made physical. When these works are actually drawn on a wall surface, it is the intention of the artist that they be painted over once the exhibition has run its course or the space is needed for something else. Their physical form is transitory, but it can be re-created at a later date; thus the

creative process extends over time. Each manifestation of the drawing is physically different because of the varying surfaces on which it is made and because of the different draftspeople making it. Yet it is the same drawing since the concept remains constant.

The situation described by the wall drawings undermines the idea of the artist's craft as a measure of value, since the drawings are made by others. It also eliminates the concept of the unchanging, unique work of art. In a traditional sense, there seems to be no artist and no art. On the other hand, the drawing responds not just to the physical aspects of each different space in which it is made, but also to certain aspects of the exhibition system that determine the feasibility of the artist's work ever being shown. It sidesteps issues such as insurance, storage, and transportation that plague curators and museums and thus connects art to the economic systems that control its availability to the public. That the wall drawing may actually be quite beautiful in its constructed form is for LeWitt a happy by-product of the conceptual system that produced it. It is a system clearly seeking an alternative to the vagaries of aesthetics as a basis for making and criticizing art.

If the idea and not the object is the site of viewers' attention then the work of art can take virtually any form. Bochner's drawing, *Triangular + Square Numbers* (cat. 23), conveys the same information—message or content would be inappropriate descriptions—when it is manifested as a three-dimensional sculpture, constructed on the floor with small pebbles along two walls at the projecting corner of a room. Bochner clearly always makes the visual form an important aspect of his work, unlike other artists who eliminated the object altogether. It was, in fact the "focus on the physical and perceptual problems in art making"[34] that had early in his career led to his interest in minimalist sculpture. In *Triangular + Square Numbers* the same numbers (1, 2, 3, 4, 5) yield different shapes as they extend from a point into triangular and square shapes, with the square form quickly outstripping the triangular one in total pieces per unit. The number of pebbles in the individual units yields interesting numerical progressions as well. The total number of pebbles in the triangles rises quite obviously using the formula (1)+2+3+4+5 . . . , while the total number of units in the squares rises in the order (1)+3+5+7+9. . . .

One could pursue such number games further, but that is not really what the drawing/sculpture is all about. If sculpture is at least in part about space and mass, then these configurations of pebbles, nearly invisible though they may be in the space of a room, say something on those issues too. The *Triangular + Square Numbers* moves from description of a point (1 pebble) to a

description of spatial areas without, however, enclosing them. Each of the forms is automatically generated; in their sequences they provide more than enough information for viewers to suggest the continuation of the rows into larger and larger squares and triangles, thus extending farther and farther along the walls and into space. But spatial relations are somewhat more complicated and they extend beyond the permeable shapes of the squares and triangles. For example, one could ask how many times the square with side two is repeated in each of the larger squares. Or one might notice that the pebbles placed against the wall are equally spaced and that the triangles are separated from one another by a width of one pebble insertion while the squares would accommodate two pebbles equally spaced between them. However, as large as the numbers of the individual squares and triangles might become, mass would always remain negligible, hugging the floor like an Andre tile piece. Once involved with space and mass and their relationships, viewers are concerned with ideas of sculpture, here achieving form solely through the use of numbers conforming to a preordained system.[35]

As a logical extension of their theory about the equation of concept with art, LeWitt and Weiner maintained that such art need never receive physical form. In "Paragraphs" LeWitt wrote that "[t]he idea itself, even if not made visual, is as much a work of art as any finished product." He amplified this belief two years later in "Sentences," writing "[a]ll ideas need not be made physical" and "[s]ince no form is intrinsically superior to another, the artist may use any form, from an expression of words (written or spoken) to physical reality, equally." Weiner's often quoted 1968 work of art in the form of a statement, carries the same message:

1. The artist may construct the work
2. The work may be fabricated
3. The work need not to be built

Each being equal and consistent with the intent of the artist the decision as to condition rests with the receiver upon the occasion of receivership[36]

This thinking, and the artistic activity that it echoes, even led some critics, most notably Lucy Lippard,[37] to postulate the end of the art object, an eventuality that obviously did not occur. But the commodity aspect of the arts was certainly under scrutiny. Freed of the physical demands imposed by the object, artists were able to present ideas that, although impossible to bring to fruition, led to new vision of their situation and their art. Dennis Oppenheim's

31

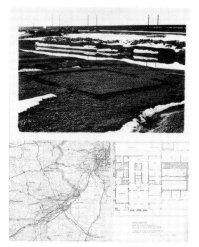

cat. 66

Gallery Transplant (Stedelijk Museum) (cat. 66), posits a move of the Stedelijk Museum to a site marked out in the landscape of Jersey City, New Jersey. The photograph does not represent the residue of an artistic event, but the projection of one, a transplantation to the United States of a European museum notable for its continuous support of new art.[38] In particular, Oppenheim was referring to a critically important early exhibition of minimalist and conceptualist art held at the Stedelijk in the spring of 1969, *Op Losse Schroeven: Situaties en Cryptostructuren (Square Pegs in Round Holes)* in which he himself had participated. In the catalogue for that exhibition he had written that the "displacement of sensory pressures from object to place will prove to be the major contribution of minimalist art" and that art would relocate itself from the loft and gallery to the landscape. *Gallery Transplant* is a homage to a great museum, a recognition of its participation in the process of change in the visual arts through its adventurous exhibition program, a witty manifestation of the very displacement that Oppenheim had spoken of in the catalogue for the 1969 exhibition.[39] Yet, in positing a site in the marshlands of Jersey City, then near the nadir of its urban history, Oppenheim may imply that, despite the high concentration of artists and critics nearby, no one would go to Jersey City regardless of how adventuresome or supportive a museum there might be. Crossing the Hudson would be harder for some than crossing the Atlantic. *Gallery Transplant* is really an exercise in wishful thinking as Oppenheim himself realized since he drew the plan of the museum in snow that would melt away, leaving the hinterland unmarked by the art it once contained.

Oppenheim's "Sunburn Piece" (cat. 67) records the location of the work of art as the artist's own body. If *Gallery Transplant* is a conceptual equivalent of landscape—or even history—painting, then "Sunburn Piece" would be a self-portrait (in the landscape). The mark on the artist's own body, a potentially painful although quite familiar one, was also as ephemeral as the mark on the landscape. Oppenheim made this work in 1970, a year of expanded social and political upheaval centered on the issue of war and violence, which provoked a number of American artists to chose self-violation as a mode of artistic activity.[40] It is no accident that the book Oppenheim displays across his chest in his "Sunburn Piece" is about military tactics. However Oppenheim is also calling attention to artistic tactics, in this case a guerilla action suggesting the transitory nature of the art object in a world determined to believe in the immutability of art. Other artists who sited their work on their own bodies chose more diurnal activities as the content. On Kawara's *I GOT UP* series (cat. 46), like his *I MET* or *I AM STILL ALIVE* series, is a dead-pan record of certain aspects of the artist's life

32

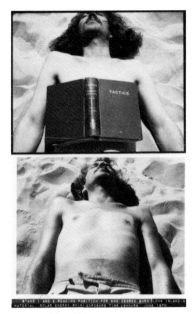

cat. 67 (detail)

"This piece incorporates an inversion or reversal of energy expenditure. The body was placed in the position of recipient . . . an exposed plane, a captive surface. The piece has its roots in a notion of color change. Painters have always artificially instigated color activity. I allowed myself to be painted— my skin became pigment. I could regulate its intensity through control of the exposure time. Not only would my skin tones change, but its change registered on a sensory level as well—I could feel the act of becoming red. I was tattooed by the sun. You simply lie down and something takes you over. It's like plugging into the solar system." Dennis Oppenheim in 1970 from *Dennis Oppenheim: Retrospective—Works 1967–1977* [exh. cat., Musée d'Art Contemporain] (Montreal, 1978), 53.

that recalls Marcel Duchamp's apparent retreat from making art after 1923. Claiming that his art was living, Duchamp thereby transformed himself from artist to art. Kawara uses commercial postcards, rubber stamps, and a type-writer to remove any residue of the artist's manual craft from his work. Only hard bits of information remain that viewers must, nonetheless, take on faith. The postcard faces and the dates record where Kawara was and when, information that is verified by the postal stamp and cancellation. Kawara also removes himself from the economic system of the art world by disseminating this postal art through the mail. Each postcard is a minimally expensive object, involving merely the cost of the card and the stamp and a few minutes of the artist's time. Yet, for a brief period of time the recipient of a sequence of the cards can track the process of the artist's activity, his progress through space and time, through a medium that is familiar to everyone.[41] As public and obsessive as this self-portrait is, like Darboven's incessant scribbles across the page, it is most notable for how little it tells the viewer about the artist. The postcard faces give a clearer "picture" of the places Kawara visited than of him. He has all but disappeared in the system and the process of his art.

5

33

> *For some, reality is not enough.*
> Robert Smithson and Mel Bochner, 1966[42]

> *The earth's surface and the figments of the mind have a way of disintegrating into discrete regions of art. . . . One's mind and the earth are in a constant state of erosion. . . .*
> Robert Smithson, 1968[43]

The landscape itself has provided a rich medium for artistic exploration in recent years. *Mudslide* (cat. 83) is an early example in Robert Smithson's thinking about the interaction of the site and the work, a concern that permeates much of the American fascination with the landscape. As a project it coincided in concept and time with his *Asphalt Rundown*, made in Rome in 1969 by dumping a truckload of asphalt down the side of a small hill. That work was to have no finite boundaries; over time it disintegrated and became indistinguishable from the landscape. Rather than merely a critique of art object as commodity, Smithson's *Mudslide* and *Asphalt Rundown* were, more important, early manifestations of his fascination with the issue of entropy, of finite objects or systems moving towards a state of undifferentiated dispersion within their

larger environments. The same is true for the cloud streams formed by the three jet planes in Douglas Huebler's projected *Site Sculpture Project* (cat. 43). Parallel trajectories, sited like minimal sculpture above the landscape, describe the artist's mental as well as physical intervention in the site.

Asphalt Rundown changed over time, like other works of art, but it was designed to do so physically not intellectually. In contrast, museums are inclined to conserve and maintain works of art in a fixed state despite their own natural inclination towards entropy. Smithson and others deliberately employed a glacial experience of time in their works in the land, where discrete occurrences—such as the development of a crack in the asphalt or the gravitational slide of a single pebble or mud down the hillside—could hardly be perceived. Thus the clock of Smithson's process runs infinitely slower than the viewers'. Smithson used the landscape as an active agent in his work, helping to focus attention on the very nature of the landscape itself rather than romanticizing it. In fact *Asphalt Rundown* is about the continual changing forces of the landscape, which become only more evident when placed in conjunction with the artist's mark on them.

Richard Long's works are also sited in the landscape, but with different concerns. His *England* (cat. 53) records his own action—picking flowers—in an archetypal English countryside, creating what he calls a line, drawn onto the landscape. Sometimes Long constructs these lines by walking in different landscape settings, sometimes he uses stones or sticks found in the landscape, and sometimes he constructs them in a museum or gallery from materials found nearby. Wherever they are—and Long has worked (walked) in very remote parts of the world like the Himalayas and the Andes—their crisp forms, even when constructed of irregularly shaped units, differentiate them from the raw form of the landscape itself. They are directional and suggest movement in time through the landscape. At the same time they are fragments, lines arbitrarily cut off, implying that the viewers' perceptions are also fragmentary. The photographic record of Long's walks is all that is left of the experience. This residue suggests that any true experience of the landscape cannot be captured artistically. Experience is immediate and personal, as ephemeral as Huebler's exhaust clouds across North America. On the other hand when Long constructs his lines in a museum space he uses stones and twigs and, for his wall drawings, mud, presenting the actual materials of the landscape rather than a fictive rendering of them in paint.

The easy reading of the lines and circles that Long uses as a system for recording space was also questioned by the Dutch artist, Jan Dibbets, in

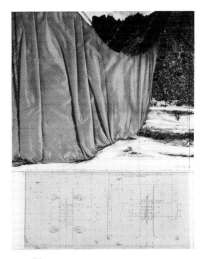

cat. 30
"What is important with the Running Fence or the Reichstag or the Valley Curtain—they are outside of that art system, and they are thrown directly into the everyday life of the country, of the community, of politicians, of the army, of circulation on streets and highways." Christo in 1979 from Barbaralee Diamondstein, *Inside New York's Art World* (New York, 1979), 89.

his early work directly with the landscape. In *Perspective Correction: Big Square* (cat. 35) Dibbets marked for the photographic lens a square on a field of grass with four stakes and a rope. The photographic canvas has all of the geometric rectitude of minimalist sculpture that Dibbets admired. Of course in order for the rope to describe a square on the flat surface of the photograph it had to be shaped as a trapezoid in the actual landscape. Thus the subtitle of the work, *Big Square*, is true only of the photograph and not of the object photographed. The big square reads as an object *on* the photographic surface while the grass, blurring from the bottom of the photograph to the top, reads as if it is moving spatially *into* the picture.

In the same year that Dibbets made the *Big Square*, Huebler also referred to conventions of perspective construction in his *Xerox Book*.[44] On one page, two aligned dots are labeled beneath A and B, the dots and the letters creating a geometry that is horizontally centered on the page. At the bottom of the page a text reads: A REPRESENTS A POINT LOCATED 1,000,000 MILES BEHIND THE PICTURE PLANE B REPRESENTS A POINT LOCATED ONE INCH BEHIND THE PICTURE PLANE. The points are of course identical, so their illusionistic distance behind the picture plane, like the vanishing point of a single-point perspective system, requires the viewers' imagination to conceive of the dots as anywhere other than on the picture surface. This is especially true in Huebler's example since no other pictorial clues are there to suggest illusionistic depth. Dibbets also deconstructed the single-point perspective system to show how artificial it was and how willingly viewers submit to visual conventions. He employed studies as deliberate as those of Renaissance artists investigating the properties of the then newly invented perspective system. Just a year later he complicated his work in the landscape by including his actual movement between specific places along the Afsluitdijk (cat. 36). Dibbets moved at a specific rate of speed, which he recorded diagrammatically and verbally on the sheet, much like some of Long's drawings. Such a restricted focus on modes of perception challenges the viewers' ability to reconstruct what they see and to describe their experience of site over time.[45]

The extension of the work over time is central to Christo and Jeanne-Claude's art as well. The Christos' site pieces exist not only as the finished work—such as *Valley Curtain, Rifle, Colorado*—but as the entire process of their construction, from the ideation of each project (cat. 30) to its ultimate removal two weeks after completion. The Christos' insistence that each project can exist only for such a short time forces attention back to the process of its creation, precludes concentration on the aesthetics of its completed

form, and undermines the commodification of the project in the landscape as an art object. The process behind their projects includes the selection of the site, usually a difficult one that requires the permission of a number of people or agencies before building can begin. The planning and construction of the work itself are usually complex, technological feats involving other groups of people, oftentimes strangers to the site. The completed physical form of the work involves both a renewed and a changed appreciation of the site. Anyone who becomes involved in the process becomes a part of the work itself, according to the Christos. Lawyers, planning boards, environmental activists, engineers, construction workers, and newspaper reporters all function as cocreators in a collaborative event that modifies the notion of the individual genius of the artists by placing it in a larger social context. Christo and Jeanne-Claude's work could not be made without the skills and participation of a large group of people. The social interaction of these people from different parts of the society is part of the content of the work, a political content that Christo learned as a student in a state art school in his native Bulgaria. There he and his fellow students were required to beautify the landscape along an international rail line so that the countryside looked prosperous and picturesque. Drawings such as *Valley Curtain* are part of the Christos' process of construction as well, insofar as they help to provide the funding necessary for the completion of the work in the landscape. They are made before the fact of the actual work and extend its life over time by involving yet another system within the society, namely the social and economic community of the art world made up of collectors and museums.[46]

The sculpture of American and European artists who work with the landscape, if compared, reveals one poignant contrast. Works by Smithson, Michael Heizer, Morris, and other Americans radically transform the landscape, often through the use of heavy machinery. This is not so of works by Christo and Jeanne-Claude, Long, Hamish Fulton, Dibbets, and other Europeans. Although the Christos do significantly transform the landscape for the two-week duration of their project, at the end of that time they carefully remove all traces of the work and return the site to its original form. Long removed the daisies from Durham Downs, but he in no way altered the fundamental shape of the land itself. Moreover Long's works are certainly modest in comparison with the huge works of Smithson and others. But then, Long's works are about one person's intimate experiences with the landscape, while Smithson's are about the primordial forces resident there. And Long's experience in England, like Dibbets' in Holland, is of a landscape precious because

of its limited extent—quite different from the expanses of rugged terrain in the American West where Smithson, Heizer, and others worked.

In addition to actual involvement in the landscape, artists have appropriated the site for art in a conceptual manner merely by claiming it in a Duchampian gesture. Oppenheim's *Site Marker No. 3* (cat. 65) consists of an aluminum marking stake imprinted with the title of the work and a plastic tube, reminiscent of a scientific specimen tube, "containing" the site in the form of a sheet locating it at C.W. Post College on Long Island and a description of the site reading like a real estate document in the specificity of its details. A document notarizing *Site Marker No. 3* as a work of art is also included in the tube and wryly comments on general perceptions of what constitutes a work of art. Here a notary rather than an art critic validated the work, circumventing the normal process by which art enters the cultural discourse. The work's ephemeral nature is thus given a permanent legal record, almost as a title to the site. Even legal real estate and artistic terminology merge in the word "title," marking the convergence of two systems of operations within the culture.

6

MANY COLORED OBJECTS PLACED SIDE BY SIDE TO FORM A ROW OF MANY COLORED OBJECTS

Lawrence Weiner, 1979[47]

If works of art in the landscape are considered in the context of the site, then the most familiar location for looking at works of art, namely the museum, might also be considered as a site, one that is far from neutral and one that is in need of contextualization. Museum installations and special exhibitions group and present objects in a serial manner along the route of pedestrian flow. Viewers often forget that both the conveniences and the conventions of exhibitions are mediated by a wide range of factors that influence their ability to see and to think about what they see. Whether rightly or wrongly, for example, museums of paintings and sculpture have the same format as ethnographic, natural history, or science museums; objects of a very diverse nature are placed one after another through the exhibition spaces. Such sequences of discrete objects seem to make each component part equally important. This could be a positive step in challenging accepted hierarchies of criticism based largely on questionable categories of quality and aesthetics, were viewers also informed about the curatorial choices that determined the objects that they do *not* see.

Even more important than the selection process that determines what viewers do see is how individual objects are shown out of their original context. Painted altarpieces, for example, were created as part of a particular decorative program which might have included frescoes and stained glass, and certainly included the architectural space, altar decorations, candles and, most important, a frame of mind on the part of the viewer far different from that of the modern museum goer. In the museum such a painting might appear, at the simplest level, as an object of aesthetic or antiquarian interest. At a slightly more complex level, it might be read historically as one situated in a particular geographical location and time.

Weiner's 1979 *MANY COLORED OBJECTS* . . . was a clarion call to take account of how works of art fail to communicate their messages at least in part because of the way in which they are exhibited. Whether placed in a commercial gallery, where it was first shown, or in a museum such as the Fredericanum in Kassel, where it existed in huge letters in German across the upper facade of the building during the *Documenta 7* exhibition in 1982, the work was carefully sited. In each case viewers could not help but make the connection between the totally anonymous objects mentioned and the art that was also shown in the same spaces. Weiner suggested that galleries and museums merely spread their commodities out in a row, sometimes ordered according to the chronological period or geographical area of the artists, sometimes according to some theme. Nonetheless, these objects provide a relentless stream of images, room after inexorable room. Weiner's sentence fragment (cat. 89) carries much the same message. MANY THINGS PLACED HERE & THERE create an environment and a patronage situation that allows MANY OTHER THINGS [to be] PUT HERE & THERE. Weiner never specifies the "objects" or "things" to which he refers, since the meaning of the works is to be determined by the site in which they appear; but insofar as they appear in a museum or gallery context, "things" certainly pricks the balloon of high-minded elitist discourse about art. Weiner implies that individual message is lost and that art becomes mere decoration in exhibition spaces. Lying behind this critique is a realization of the commodification process that has long been part of the world of art, even when objects were located in their original sacred spaces.[48] Other twentieth-century artists, like Weiner, critiqued the commodity status of art. Dieter Roth's organic works, such as *Insel* (cat. 75), respond to the environment and disintegrate over time. They thus contradict the function of preservation so central to museums.[49] Christo's *Package* (cat. 31) actually denies the viewer access to the object presumably hidden under the

wrapping. The package becomes the object itself and suggests that it is wrapped, as a commodity, for transport. *Package* presents a tantalizing suggestion of a secret to be uncovered; but to reveal whatever is hidden would be to destroy the work of art.

Artists like Daniel Buren have suggested that exhibition sites are not anonymous, empty spaces, that they have hidden histories and hidden agendas. For him, the history of the art that has already appeared in them will significantly affect the art that will appear there in the future. This accumulated history, like that implied in Oppenheim's *Gallery Transplant*, builds a clear character for any exhibition space and determines viewers' expectations of what they will see there. Viewers need to be aware of these expectations—as LeWitt stated in 1967—when confronting works of art, especially new ones. In October 1973, Buren strung a rope through the length of the John Weber Gallery on West Broadway and out an open window to a building across the street. From the rope he hung a series of evenly spaced, identical striped banners. Outside, the casual passer-by perceived the banners as street decoration, perhaps like those used for festivals in the Italian neighborhood nearby. In the gallery, people read *Within and Beyond the Frame*, as it was called, as art because they were predisposed to consider the gallery space as the defining frame for art, despite the fact that all the banners, inside and out, were identical. Buren's medium is always commercially produced striped canvas cloth or comparably striped paper. His craft is limited to painting the end white stripes of the canvas with white paint, a white on white that makes his "hand" all but invisible. This intervention nevertheless frames the image and indicates that it is not a haphazard found object. In *Within and Beyond the Frame* Buren asked viewers to consider what is in the frame, what the limits of the frame are, and who determines them.[50] How discrete, or even discreet, should art be? And how narrow a frame should be constructed for experiencing the art?

Buren's untitled work (cat. 26) in the Vogel collection from this same time poses some of the same questions. It is after all only a piece of striped cloth, preprogrammed for Buren to add the white pigment to the outside stripes. Placed on the museum wall, however, it has the curious property of belonging because its shape resembles other objects in the museum. In this case, however, Buren has stipulated that the work be exhibited in a corner, folding around two sides of the room. He deliberately chose a place where no paintings ever hang, an empty space to fill with his "painting." The space, or the envelope which frames the exhibition, is thus brought to the viewer's attention as the content of the work. The work itself is a blank suggesting

cat. 85

absence; nothing is there. That's the point. When Buren was asked in 1975 to exhibit at the Städtisches Museum in Monchengladbach, he asked to have all the paintings in the museum removed to storage. He papered all the walls with striped canvas—except the places where the paintings had been. The Vogel piece likewise raises these questions about the site and its normal use. What conventions govern the use of the museum space and how have they been determined? And how, for example, does a visitor to the National Gallery of Art understand those conventions? As a final comment on the museum, Buren's work, like other aspects in the Vogel collection, has no meaning other than as an installation. Folded up and put in storage it is merely a striped cloth with its peripheral stripes painted.

Some of Richard Tuttle's works also consider expectations of the gallery visitor. *White Cotton Octagonal* (cat. 85) and *Monkey's Recovery for a Darkened Room (Bluebird)* (cat. 86) are cases in point.[51] The octagon was made in 1971 when minimalist forms were at the center of critical attention. *Monkey's Recovery* was made when a new painterly expressionism was being hyped by the galleries and the media. In each case, Tuttle responded to the then current gallery-driven fashion, only to turn it inside out. Tuttle's *White Cotton Octagonal* is a definite geometrical shape, but one gone soft. It would be all but invisible on a gallery wall, very unlike the massive hard forms of minimal sculpture. Its rough texture and unprecious, careless quality are certainly different from the painstakingly worked, smooth surfaces of Marden's paintings, for example. Whereas the so-called neo-expressionism of the 1980s was painting on a very large scale, Tuttle's small *Monkey's Recovery* is truly a minimal work. Even so, it refers to techniques used by a painter like Julian Schnabel, who obsessively collaged his painting surfaces with detritus of one sort or another. Of course *Monkey's Recovery* is also in the tradition of Pablo Picasso's scrap sculpture. Moreover its wit and "off-the-wall" charm are directly opposed to the ponderous and angst-ridden imagery of the neo-expressionists. Going into the New York gallery that first exhibited *Monkey's Recovery*, one could not help but be amused at the way Tuttle had turned the whole art world system, with its hype and pretensions, on its end with a few small scraps. And, the artist still managed to produce a wonderful work of sculpture. Or is it a painting?

Robert Barry played a trick on gallery goers in 1969 that was intended to raise some of the same issues about viewers' expectations. In *Closed Gallery* (cat. 12), Barry scheduled an exhibition at the Art & Project Gallery in Amsterdam that was announced in the gallery's *Bulletin,* a regular publication accom-

cat. 12

panying each of its shows. Upon arrival at the gallery, the viewer found a note on the door indicating that for the duration of the exhibition the gallery would be closed. This was a literal rendering of Duchamp's ballet *Relâche* ("Canceled"), which was, because of an accident, shut down for the first evening of performance. *Closed Gallery* marks the curious act of an artist apparently making his art inaccessible to the viewing public. *Closed Gallery* records through printed materials the act of closing the gallery. This action is owned conceptually by the Vogels. The site literally became empty, a conceptual provocation to consider the nature of the event programmed.

7

ALL THE THINGS I KNOW BUT OF WHICH I AM NOT AT THE MOMENT
THINKING
1:36 PM; JUNE 15, 1969

Robert Barry, 1969

*. . . I use words because they speak out to the viewer. Words come from us. We
can relate to them. They bridge the gap between the viewer and the piece.*
Robert Barry, 1986[52]

If Barry's exhibition and some of his early word pieces existed in thought, that thought could only take shape through words. Insofar as language structures the understanding of what is seen and translates from the visual to the verbal, it is an integral part of the artistic experience. However language is most often submerged by the romanticism of emotional charge that, it is said, art is supposed to carry. One of the interesting developments in the art of the seventies

was the incorporation of language into the work of art. More important, it even became the very medium of art. It removed the intermediary step of the art object between the artist's idea and the public's reception of the idea.[53] This use of language was unlike the use of systems that had responded to traditional compositional strategies or the definitional search of minimalist art, and unlike the use of action that could be seen as a reference to performance or to the artist's activity and thus to action painting. Language seemed to be a category that existed almost in opposition to the visual arts. After all, isn't a picture worth a thousand words?

Yet the use of language is conventional in the history of art, most powerfully revivified at the beginning of this century by Picasso and other cubist painters and at mid-century by Johns and Pop artists like Roy Lichtenstein.[54] Art has virtually always had words physically attached to it, whether in the inscriptions on Greek statues, labels on bands under saints in Renaissance painting, texts issuing from the mouths of represented figures like modern cartoonist's balloons, or even—most obviously and thus most ignored—as artists' signatures. These words were directed to the viewer and were intended as aids in understanding; they identified the Greek hero and the town that commissioned the statue, the saint who was represented, the subject being depicted, or the artist who had painted the picture—just as Bochner, for example, wrote TRIANGULAR + SQUARE NUMBERS MEL BOCHNER 1972 (cat. 23) on his drawing that documents a sculpture. In all these cases, and in countless others like them, the words provide information. On occasion, however, that information is redundant. For example, a familiar saint, recognizable by the attributes that he or she carried, did not need to be labeled by name to be recognized. Yet, such labels do appear as a validation of the visual, historical, or cultural information already possessed by the viewer. In all of these instances words are elements of clarification and explanation. Even in instances of aniconic traditions such as Islamic art, in which figural representation is forbidden for religious reasons, words spread on a page or over an architectural surface, regardless of—or perhaps because of—the beauty of their design, are used to convey the text.

In the European artistic tradition, if words are disconnected from an obviously pictorial or sculptural matrix, separated from the object they were meant to describe, they lose their ability to exist in the category of art. Thus in objects made by artists like John Baldessari, Barry (cat. 13), and Weiner (cats. 87, 89), in which the word seems to have displaced the work of the artist, it may be difficult at first to reference such words to artistic activity. It

cat. 47

may be especially difficult when these words are presented in a completely blank manner oftentimes imitating the printed page, as in Kawara's three 1963 pencil and letraset drawings of bold black letters on white paper of NOTHING, SOMETHING, and EVERYTHING and Baldessari's 1967–1968 acrylic canvases with black block letters on a nondescript white ground carrying messages such as A TWO-DIMENSIONAL SURFACE WITHOUT ANY ARTICULATION IS A DEAD EXPERIENCE.[55] This dead-pan labeling of the object within the object itself inextricably binds the message and medium. Such paintings refer to the use of words in advertising and newspapers. They also refer to the insistent use of fragments of phrases and words in Pop painting; yet they are referenced to nothing outside the object itself. Joseph Kosuth's photographic prints of definitions, such as *Art as Idea: Normal* (cat. 47) and *Art as Idea: Nothing* (cat. 48) are in the same typeface that one might find in a dictionary. But of course these large images by Kosuth are not quite what they seem to be, any more than Lichtenstein cartoons are reproductions of actual cartoons. They are, after all, negative images, suggesting, like John Cage's *Lecture on Nothing*, that nothing is something. Kosuth's definitions are also separated from the page on which they were found, and blown up to a large scale, like Pop images, although they have all the fun and hype of cartoon and advertising images drained out of them. They appear both literally and metaphorically, black and white. But what does it mean to look at "nothing"; is that even a physical possibility? Doesn't looking presuppose an object? Here perhaps the questions begin to echo similar ones posed by Buren. Why go to a museum to look at nothing, or, as the definition in Kosuth's image says in its last two words, "no thing"? Does all this looking at objects in a museum amount to looking at nothing? Clearly the meaning of the work is dependent upon its placement within a context—like an artist's studio, a gallery, or a museum—that says art. Were it placed on a wall in a school room, *Nothing* might take on slightly different interpretations. It is interesting that neither *Nothing* nor *Normal* has anything in the definition that relates it to art, unless "model" or "pattern" can be thought to do so. These words suggest replication, like the photographic print itself, and question one of the fundamental tenets of the museum—its collection and conservation of unique, and therefore precious, objects.

 Normal questions the normative and thus perhaps the selection process that determines what gets placed on museum walls. Similarly, *Nothing* opens discussion about the entire process that gives a viewer access to works of art and what his or her role might be at the end of that process. Kosuth's famous tripartite object, *One and Three Chairs*, is composed of a dictionary defi-

fig. 5. Robert Barry, *Untitled*, 1987, acrylic and enamel on canvas, 20 x 20 in. The Dorothy and Herbert Vogel Collection

44

nition of "chair," much like *Nothing*; a simple wood folding chair; and a photograph of that chair blown up to actual size. It deals with the ability of the words to convey an image of "chair." But, it also deals with the power of the image to present the chair, since the photographic image seems badly distorted in relation to the actual form beside it. Of course the words in *Chair* define a concept of chair, not the particular chair shown. The relationship of verbally and visually described images to the real object remains the central issue of the piece. This relationship is central to artistic activity itself and to the critics' description of its results. Kosuth's use of words, then, relates to a viewer's ability to formulate a response to any art, given that the response depends upon very fragile words.[56] It was just this intervention of language that Bochner believed was central to conceptualist art: "What I . . . see as the value of conceptualism is the focus on language itself as an important aspect of the experience of an art work. I think it's the first time in which the way ideas are formulated became a critical part of the work."[57]

Barry is less didactic than Kosuth in the incorporation of words into his painting. His words are always single objects or fragmentary phrases floating on a surface. In his untitled work of 1987 in the Vogel collection (fig. 5), words such as "alone," "extraordinary," "doing," and "often" appear in block letters at corners and borders of a small yellow painting divided sharply in half by a slight diagonal. Nothing modulates the surface of the painting. The words reinforce its flatness both by their placement at the edges of the painting and by the consistently thin, crisp letters that appear almost to be printed on the surface. The words are not referenced to anything in the painting and they cannot be formed into any syntactically coherent sentence. The viewer can meditate upon each word individually or combine them at will so that "often alone," "often doing," and "often extraordinary" are all possible readings. Barry does not provide any nouns, so viewers reading the words place themselves as the subject of the descriptive adjectives and thus place themselves "in the painting." The verbs are in the gerundive form, suggesting an action, doing, that is undefined in terms of its beginning and end. The verbs are also quite nondescriptive, demanding that the viewer imagine the nature of the action—"doing" *what*?

Each viewer will respond to words differently, depending upon his or her own background and each is responsible for extending the creation of the work by his or her reading of the words. One is reminded of Duchamp's *Tu m'* of 1917; the viewer completes the painting by providing a verb, an action that itself affects any reading of the various objects in the painting. In Barry's paint-

ing, states of being, "alone," issues of quality, "extraordinary," and actions, "doing," can be thought of in connection with conventional subject matter, critical evaluation, and artistic activity. Although Barry maintains that his words are not chosen in a premeditated manner, they nonetheless extend the meaning of the work to the critical issues of the nature and reception of art. Barry's *LOVE TO (Study for Wallpiece)* (cat. 13) raises the same issues of how ideas become shaped. As large as the wallpiece (cat. 13A) is and as strong a presence as it exerts in the gallery space through its primary color, its thin, fragile lettering and inverted TO signal the ambiguity of meaning conveyed. The viewer has to complete the infinitive for the two words, unless they are read as a simple, throw-away exclamation or a homophonic word game—as "Love, too." With the TO inverted, the drawing could just as easily be read as "To Love." This phrase is also incomplete and ambiguous since the infinitive lacks an object or could, itself, be read as a noun phrase—like Hamlet's "To be or not to be," here bereft of a verb to give it meaning. Ambiguity and uncertainty do not signal a lack in the work, but a transfer of the creative process to the viewer. Each person can participate in the process of creativity through an active engagement of imagination and of thought. The very clarity of the blue wall of *LOVE TO* and the translucence of the papers Barry uses for his drawings provide a scrim for the individual imagination prodded by the artist's words.

Some of the same verbal conventions are used by Weiner, the only artist in the Vogel collection to work solely with words. In *BROKEN OFF* (cat. 87), thick block letters are painted directly on the gallery wall. But they do not have a clearly delimited ground as do Barry's letters in *LOVE TO*. Weiner's letters appear as a label, or a descriptive tag for the wall of the building that then becomes the ground for the work. Rather than merely placing something on a wall, Weiner incorporates the wall itself into the work. But as a label, *BROKEN OFF* is absurd. Conversations are broken off, pieces of bread are broken off, but the wall is clearly not broken off. What could such a phrase, suggestive of a fragment, mean in a museum or gallery space? As a label for an entire wall, it appropriates a considerable space within the museum and separates the space in its blankness from other exhibition walls that are filled with objects. As a part of the whole, this metonym asks for a consideration of the museum and the activities that take place there, as it would for any space in which it was exhibited. The content is not inside the piece as with conventional works of art. The content is outside the piece as viewers rethink the function of the entire space to which it is connected—and of the entire culture from which it is "broken off."

The history of recent art is, of course, even much more complicated and challenging than the one outlined above. In the United States, for example, there is a distinctive West Coast sensibility far different from the focused intensity of New York. The slightly off-center humor of someone like Ed Ruscha is a case in point. *Colorfast?* (cat. 76) is simultaneously a response to color field and Pop. Stained with beet juice, this health food painting is true to its title, as anyone who has tried to remove beet stains will attest. Or is it, since Ruscha deliberately punctuates the title of this faded work with a question mark? *Colorfast?* is certainly a painting removed from the concentrated seriousness of the New York art discussed. Yet in its wit, it is nonetheless conscious of the very issues that underlie the work of Ruscha's fellow artists in New York. Baldessari, also based in California, poked fun at the high-minded discussions and theorizing about the nature of art in his 1967–1968 white canvas carefully lined with black letters that read: EVERYTHING IS PURGED FROM THIS PAINTING BUT ART, NO IDEAS HAVE ENTERED THIS WORK.

None of the artists in the Vogel collection point up the differences between European and American art as sharply as Joseph Beuys. He began his career as an artist shortly after World War II and thus had to face the challenging questions about how to make art in an emotionally, physically, and economically devastated environment. Like artists in other countries in postwar Europe, he faced a situation in which the very traditions of his profession had been severed in profound and seemingly unrecuperable ways. Artists had emigrated from Paris as a result of the war, leaving a vacuum that neither Matisse nor Picasso—who had remained, but in the south—were able to fill. But in Germany the situation had been much more politically charged, with a national art twice deracinated within a period of little more than a decade. In 1937 the Nazi party officially condemned German cubist and expressionist traditions as "Degenerate Art" and removed artists working in such styles from teaching positions throughout the country. A popular, propagandistic figural realism, championed by Hitler, replaced the proscribed art specifically to support the claims of the state. At the end of the war this official state art itself was automatically proscribed because of its ties to the Nazis. It took nearly twenty years and the powerful visions of artists like Georg Baselitz, Gerhard Richter, and Sigmar Polke—emigrating from then East Germany—before the figure could be reintegrated into the mainstream of German art. Even then, the figure was radically altered to make clear its political underpinnings.

cat. 20

At the end of World War II artists like Beuys were faced with reinventing German art. He chose not to assimilate the style of abstraction made internationally prominent by American artists and the American government, refusing to submit to what would have amounted to a cultural colonization. Instead, Beuys sidestepped stylistic issues by reinventing himself as artist. He fabricated a personal history and adopted a shamanistic persona in carefully planned performance pieces that explicitly and implicitly dealt with political issues of social organization.

Central to the myths of Beuys' constructed autobiography was the tale of his rescue by Bedouin tribespeople after his plane had been shot down in the Crimea during the war. His return to life was a metaphor both for his art and for the German nation. Thus it is not surprising that small, usually red, crosses appear frequently in his work and as stamps in his drawings. He had begun his sculptural career by making tombstone-like images that essentially buried the past. He then repeatedly reinforced the healing power of the "present," even if change meant challenges to established social and political structures. His open classroom was in defiance of the admissions policies of the art school in Düsseldorf where he taught. His proposed new political party was an alternative to existing political organization. Beuys' drawings (cats. 19, 20) are fragmentary notes in the progress of social change, triggering actions, like Barry's singular words, for further thought.

It is telling that European artists were the first to turn to sociopolitical issues in a direct way as the content for their art after World War II. Separated from their earlier artistic histories and traditions, they faced the problems of reconstruction in different ways that depended on their home countries. Even when they emigrated to the United States, artists like Christo maintained a sharply focused political content in their work. Art with a sharp political content and agenda by American artists was, for the most part, not refreshed in the United States until the field of participants in the artistic community opened to include women and minorities.

9

Artists like those in the Vogel collection and critics as well now think much more provocatively about art as a system of interlocking forces—creative, commercial, and political—mediated for the viewer by systems of evaluation, both commercial and critical. This is owing, in some significant measure, to the work of artists represented in the Vogel collection. There is a greater

awareness of how and where art does—or does not—act in the modern world and the sites chosen for this activity. The proliferation of styles and artistic production during the last half century shows that artists are searching for new forms of visual language. Viewers need to be ever more aware of how they use language to criticize and to explain what artists have done. If nothing else, these artists require perceptive and precise evaluation.

The works in the Vogel collection are about the very nature and experience of art itself. They represent for the first time in the Western tradition such a radical investigation into the communicative properties of works of art and the surroundings in which they are perceived. In 1983 Barry referred to the importance of this restructuring of thought in the following manner:

> . . . conceptual art was not an end in itself . . . I mean, conceptual art revealed certain aspects of art to us, which are very important. It was a very important time, a very important movement, which is unfortunately still neglected. I don't think the art establishment quite knew what to do with it, at least in America. And it still doesn't.[58]

A decade later perhaps this exhibition will begin to redress the situation described, unfortunately all too accurately, by Barry. The questions raised by the works in this exhibition are important and provocative ones, especially when they fly in the face of common predispositions towards an art that is either aesthetically pleasurable or narratively direct. The questions are not easy and they are not asked in a condescending manner. But they provide the most far-reaching and regenerative possibilities for art in our time.

Notes

1. This letter, written to an unknown cardinal who had obviously urged Michelangelo to get on with his painting for Pope Paul III, details problems with the still incomplete marble tomb of Julius II begun in 1505; see Robert N. Linscott, ed., *Complete Poems and Selected Letters of Michelangelo*, trans. Creighton Gilbert (Princeton, 1963), 258–265. It is included here to suggest that there has never been a time without conceptual art.

2. Alanna Heiss provides one of the bluntest statements of this situation in the introduction to her catalogue for an exhibition of the work of Dennis Oppenheim: "I went to London for a while, and when I returned to New York in 1970, America was the landscape of the Manson murders, the moon landing, and the Vietnam War." See Alanna Heiss, *Dennis Oppenheim: Selected Works 1967–90* [exh. cat., The Institute for Contemporary Art] (New York, 1992), 5. Klaus Kertess also mentions the sixties as a time of upheaval in his discussion of Brice Marden's early painting; see *Brice Marden: Paintings and Drawings* (New York, 1992), 17–18.

3. Seth Siegelaub, "Some Remarks on So-Called Conceptual Art," in *l'art conceptuel, une perspective* [exh. cat., Musée d'Art Moderne de la Ville de Paris] (Paris, 1990), 92; quoted by Robert C. Morgan, "A Methodology for American Conceptualism," in *Art Conceptuel Formes Conceptuelles/Conceptual Art Conceptual Forms*, ed. Christian Schlatter [exh. cat., Galerie 1900 Δ 2000 and Galerie de Poche] (Paris, 1990a), 556–569.

4. Thomas B. Hess, *Barnett Newman* [exh. cat., The Museum of Modern Art] (New York, 1971).

5. *Life*, 27 (8 August 1949), 42–43, 45.

6. Donald Judd raised this issue as late as 1975 in "Imperialism, Nationalism and Regionalism." Judd quoted Jackson Pollock, who had early on spoken out against the notion of an American art by saying "[t]he idea of an isolated American painting, so popular in this country during the thirties, seems absurd to me, just as the idea of creating a purely American mathematics or physics would seem absurd. . . ." Judd then stated: "[i]n the forties and even in the fifties art magazines in the United States worried about whether art made there could equal art made in Europe. Art magazines in Europe ignored or despised art made in the United States." See *Donald Judd: Complete Writings 1959–1975* (New York, 1975), 221.

7. The publications that helped to focus attention on this topic are: Max Kozloff, "American Painting during the Cold War," *Artforum* 11 (May 1973), 43–54; William Hauptman, "The Suppression of Art in the McCarthy Decade," *Artforum* 12 (October 1973), 48–52; Eva Cockcroft, "Abstract Expressionism, Weapon of the Cold War," *Artforum* 12 (June 1974), 39–41; and Jane DeHart Mathews, "Art and Politics in Cold War America," *American Historical Review* 81 (October 1976), 762–787; see also Casey Blake, "Aesthetic Engineering," *Democracy* 1 (October 1981), 37–50 and Cecile Whiting, *Antifascism in American Art* (New Haven, Conn., 1989), as background material.

8. For a presentation of the politics within the group of abstract painters of the first generation see Annette Cox, *Art-as-Politics: The Abstract Expressionist Avant-Garde and Society* (Ann Arbor, Mich., 1982).

9. Lucy Lippard and Robert Smithson, eds., "Fragments of an Interview with P.A. Norvell, April 1969," in Lucy Lippard, ed., *Six Years: The Dematerialization of the Art Object from 1966 to 1972* (New York, 1973), 87.

10. Mel Bochner, "Statement for *Flash Art*" (unpublished manuscript written July 1988).

11. "I do believe that chaos and form are . . . it's the same." In Jochen Poetter,

ed., *Chaos die/the Form* (Stuttgart, 1993), unpaginated.

12. Elaine A. King, *Douglas Huebler 10+* [exh. cat., Dittmar Memorial Art Gallery, Northwestern University] (Evanston, Ill., 1980), unpaginated; also found in Ronald J. Onorato, "Douglas Huebler: A Responsibility of Forms," in *Douglas Huebler* [exh. cat., La Jolla Museum of Contemporary Art] (La Jolla, Calif., 1988), 31.

13. Sol LeWitt, "Paragraphs on Conceptual Art," *Artforum* 10 (Summer 1967), 79–83.

14. For Robert Ryman, see *Robert Ryman* [exh. cat., Dia Art Foundation] (New York, 1988) and Robert Storr, *Robert Ryman* [exh. cat., Tate Gallery] (London, 1993).

15. For a discussion of Marden's work see Kertess 1992.

16. For a catalogue raisonné of the works of Robert Mangold to 1982 see *Robert Mangold: schilderijen/paintings 1964–1982* [exh. cat., Stedelijk Museum] (Amsterdam, 1982).

17. See *Carl Andre—Sculpture 1958–1974* [exh. cat., Kunsthalle Bern] (Bern, 1975), 5.

18. For a recent discussion of Andre's sculpture see Rolf Lauter, *Carl Andre: Extraneous Roots* [exh. cat., Museum für Moderne Kunst] (Frankfurt, 1991).

19. For the work of Donald Judd, see Barbara Haskell, *Donald Judd* [exh. cat., Whitney Museum of American Art] (New York, 1988) and *Donald Judd* [exh. cat., Staatliche Kunsthalle Baden-Baden] (Baden-Baden, 1989). Judd's own writing was anthologized early in his career; see *Donald Judd* 1975.

20. For recent discussions of minimalism see Hal Foster, "The Crux of Minimalism," in *Individuals: A Selected History of Contemporary Art 1945–1986* [exh. cat., The Museum of Contemporary

Art] (Los Angeles, 1986), 162–183. For an early response to minimalism see E. Develing and Lucy Lippard, *Minimal Art* (The Hague, 1968). The standard compilation of essays on minimal art is Gregory Battcock, ed., *Minimal Art: A Critical Anthology* (New York, 1968). The most recent treatment of minimalism as a discrete artistic phenomenon is Frances Colpitt, *Minimal Art: The Critical Perspective* (Ann Arbor, Mich., 1990); this book includes a thorough bibliography and a very useful appendix of "Exhibitions and Reviews, 1963–68" so that one can track the appearance and critical reception of minimalist art. A useful discussion of this topic sited specifically in works from the Vogel collection is *Jenseits des Bildes/Beyond the Picture: The Dorothy & Herbert Vogel Collection, New York* [exh. cat., Kunsthalle] (Bielefeld, 1987) with works by Robert Barry, Sol LeWitt, Robert Mangold, Richard Tuttle and an essay by Vivian Endicott Barnett on the Vogels and their collection.

21. The most recent discussion of Mangold's work, containing a complete bibliography, has to do with her prints; see Ellen G. D'Oench and Hilarie Faberman, *Sylvia Plimack Mangold: Works on Paper 1968–1991* [exh. cat., Davison Art Center, Wesleyan University and University of Michigan Museum of Art] (Middletown, Conn., and Ann Arbor, Mich., 1992).

22. For a presentation of Close's portrait paintings, drawings, and photographs, see Lisa Lyons and Robert Storr, *Chuck Close* (New York, 1987).

23. For a discussion of Bartlett's painting see Marge Goldwater, Roberta Smith, and Calvin Tomkins, *Jennifer Bartlett* [exh. cat., Walker Art Center] (New York, 1985).

24. For a history of Artschwager's sculpture, see Richard Armstrong, *Richard Artschwager* [exh. cat., Whitney Museum of American Art] (New York, 1988).

25. For Benglis' work to date see Susan Krane, *Lynda Benglis: Dual Natures*

[exh. cat., High Museum of Art] (Atlanta, 1990). For additional discussion of the feminist issues of Benglis' work, see Lucy R. Lippard, "Intruders: Lynda Benglis and Adrian Piper," in *Breakthroughs: Avant-Garde Artists in Europe and America, 1950–1990* [exh. cat., Wexner Center for the Arts, Ohio State University] (Columbus, Ohio, 1991), 125–131.

26. The most recent discussion of Eva Hesse's work was provoked by a retrospective exhibition of her painting, sculpture, and drawing; see Helen A. Cooper, ed., *Eva Hesse: A Retrospective* [exh. cat., Yale University Art Gallery] (New Haven, Conn., 1992).

27. LeWitt 1967.

28. "Excerpts from Speculation [1967–1970]," *Artforum* 8 (May 1970), 70–73.

29. "Discussion Robert Barry & Robert C. Morgan," in Erich Franz, ed., *Robert Barry* (Bielefeld, 1986), 65.

30. LeWitt 1967. There are earlier instances of the use of this term in the literature, but LeWitt's publications provided a focal point for discussion of the concepts implied by the term and inserted the word as a permanent, rather than an incidental, term in our critical language. For references to earlier uses of the term, see Benjamin H. D. Buchloh, "Conceptual Art 1962–1969: From the Aesthetic of Administration to the Critique of Institutions," *October* 55 (Winter 1990), 105–143. For an early compendium of artists' statements about conceptual art and indications of their work see Ursula Meyer, *Conceptual Art* (New York, 1972). The most recent presentation of the international scope of art that fell under the conceptual umbrella is Paris 1990a. The first major exhibition to use the term was *Konzeption/Conception* at the Stadtisches Museum in Leverkusen in 1969; see also note 39.

31. Sol LeWitt, "Sentences on Conceptual Art," in *0–9*, (New York, 1969) and in *Art-Language* 1 (May 1969), 11–13; "Sentences" is also reprinted in Meyer 1972, 174–175.

32. For a statement about the necessary connections between conceptual art and modernism see Charles Harrison, "Conceptual Art and Critical Judgement," in Paris 1990a, 538–545. Mary Anne Staniszewski, "Conceptual Art," *Flash Art* 143 (November–December 1988), 88–97 provides a succinct view of early conceptualist art and also critiques its ties to modernism.

33. Wall drawing no. 73; see Susanna Singer, ed., *Sol LeWitt Wall Drawings 1968–1984* [exh. cat., Stedelijk Museum, Stedelijk Van Abbe Museum, and Wadsworth Atheneum] (Amsterdam, Eindhoven, and Hartford, Conn., 1984).

34. Mel Bochner interviewed by Jacopo Benci in "The Archeology of Doubt," *891* 6 (June 1986), 8–13 and on 10: [a specific critique of using the term "conceptual" in a too general and uninflected manner] ". . . to see my works as conceptual art was to cut off a dimension. . . . There is no art which exists purely as thought. I think that in general the art of that period was an iconoclastic reaction to the indulgences of the period directly before. . . ."

35. See *Mel Bochner, 1973–1985* [exh. cat., Carnegie-Mellon University Art Gallery] (Pittsburgh, 1985). Bochner's writing, like other artists questioning the object, has also been extensive. For his discussion of the object see "Art = Idea ± the Object: Talking with Mel Bochner, 18 April 1972," in *Modern Art and the Object* (New York, 1976), 204–215.

36. This statement has been constantly repeated in the literature on Weiner. It is printed in Gerd de Vries, ed., *On Art: Artists Writings on the Changed Notion of Art after 1965* (Cologne, 1974), 248. In the exhibition catalogue produced by Seth Siegelaub, *January 5–31, 1969* [exh. cat., independent show at 1100 Madison Avenue] (New York, 1969), Siegelaub stated that: "[t]he exhibition consists of

[the ideas communicated in] the catalog; the physical presence [of the work] is supplementary to the catalog." Siegelaub was one of the earliest supporters of a type of artistic practice that has come to be known as conceptual art.

37. See Lippard 1973 and Mel Bochner's review of it in *Artforum* 11 (June 1973), 74–75. A European response to Lippard's critically important publication can be found in Germano Celant's books, which employ the same diaristic presentation: see *Precronistoria 1966–1969: minimal art, pittura sistemica, arte povera, land art, conceptual art, body art, arte ambientale e nuovi media* (Florence, 1976) and *Arte Povera/Art Povera* (Milan, 1985).

38. For a recent discussion of the work of Dennis Oppenheim see Alanna Heiss in New York 1992.

39. Other artists in the Vogel collection who participated in the *Op Losse Schroeven* exhibition were: Andre, Beuys, Dibbets, Huebler, Long, Morris, Ryman, Saret, Smithson, and Weiner. The historical facts indicate that many of the American artists in this exhibition have received greater attention in European museums than in the art institutions of their own country. Most notable among these exhibitions were: *When Attitudes Become Form/Works—Concepts—Processes—Situations—Information*, Kunsthalle Bern, 1969; *Documenta 5*, Kassel, 1972. In Italy this art was championed under the title Arte Povera by critics like Germano Celant, who began curating a series of exhibitions under that name in 1967, published his first article on this art, "Arte povera. Appunti per una guerriglia," *Flash Art* 5 (November–December 1967), and a book with that title in 1969; see Celant 1985. Perhaps the most important of the very rare museum shows in this country early in the history of conceptualist art was the *Information* show curated by Kynaston L. McShine at the Museum of Modern Art in New York in the summer of 1970. The catalogue for this show is still one of the primary documents of conceptualist art; twenty-two artists represented in the Vogel collection participated in that exhibition. It was preceded that same year by two somewhat smaller exhibitions: *Conceptual Art and Conceptual Aspects* at the now defunct New York Cultural Center and *Art in the Mind* at Oberlin College. The last major American exhibition of this art was at the Art Institute of Chicago, *Europe in the Seventies: Aspects of Recent Art* in 1977, with an important catalogue edited by A. James Speyer and Anne Rorimer. Exhibitions such as *Op Losse Schroeven* and the other European shows were important for bringing together in a single place artists—not just art—from both Europe and America in an environment conducive to discussion and exchange. A book has yet to be written that details the influence of such exhibitions on the development of the arts of the sixties and seventies.

40. This activity peaked at a performance exhibition in the La Jolla Museum of Contemporary Art during that year in which a number of artists like Oppenheim (*Rocked Circle*) and Barry LeVa (*Velocity Piece #2*) used their own bodies as the site of violent action.

41. For On Kawara's early career see *On Kawara: continuity/discontinuity 1963–1979* [exh. cat., Moderna Museet] (Stockholm, 1980).

42. "The Domain of the Great Bear," *Art Voices* (Fall 1966); Reprinted in Robert Smithson, *The Writings of Robert Smithson* (New York, 1979), 24–31.

43. "A Sedimentation of the Mind: Earth Projects," *Artforum* 7 (September 1968); Reprinted in Smithson 1979, 82–91.

44. *Drawings from the Xerox Book* (New York, 1968). This artist's book was produced by Seth Siegelaub and Jack Wendler.

45. For a discussion of Dibbets' work see *Jan Dibbets* [exh. cat., Walker Art Center] (Minneapolis, Minn., 1987); the catalogue includes an illustration of the Vogels' *Perspective Correction*.

46. For complete information on the Valley Curtain project see *Christo: Valley Curtain* (New York, 1973).

47. This work was first shown at the Leo Castelli Gallery, New York, in 1979 and has been exhibited in other sites since; it is owned by Annick and Anton Herbert, Ghent, Belgium.

48. For a discussion of Weiner's work, see *Lawrence Weiner* [exh. cat., Stedelijk Museum] (Amsterdam, 1988) and Anne Rorimer, *Five Figures of Structure* [exh. cat., The Chicago Arts Club] (Chicago, 1987). For a compendium of the work see *Lawrence Weiner: Specific & General Works* (Villeurbanne, 1993).

49. Dieter Roth has assumed a number of names during his career. The one by which he is best known, Dieter Rot, is a play on words; it suggests both the rotting of his art over time and "red" ("rot" in German) as a reference to political sympathy. Homophonically it refers to Diderot, the French philosopher whose *Encyclopédie* was an important determinant for later discussions of art and aesthetics.

50. Daniel Buren has written extensively on the issue of the siting of the work of art; for a collection of texts translated into English see his *Five Texts* (New York and London, 1973). The most recent compendium of Buren's writing is *Les écrits 1965–1990*, 3 vols. (Bordeaux, 1991).

51. For a retrospective presentation of Tuttle's work and an interview by Richard Marshall of Dorothy and Herbert Vogel in which they talk about the Tuttle pieces in their collection see *Richard Tuttle* [exh. cat., Institute of Contemporary Art] (Amsterdam, 1991), 66–85 for the interview. See also Bielefeld 1987.

52. Franz 1986, 75, and on 95: ". . . I try to make it very basic, very direct. I mean, it's really meant for anyone."

53. For an extensive discussion of language see Anne Rorimer, "Photography—Language—Context: Prelude to the 1980s," in Catherine Gudis, ed., *A Forest of SIGNS: Art in the Crisis of Representation* [exh. cat., The Museum of Contemporary Art] (Los Angeles, 1989), 129–153. Critics have, of course, pointed out that the support for the words, whether it is a gallery wall or an exhibition catalogue, is an object too, regardless of its previous condition or traditions.

54. For a brief discussion of the role of language—or simply words—in the arts of the twentieth century see Thomas McEvilley, "I think therefore I art," *Artforum* 23 (Summer 1985), 74–84.

55. For the most complete presentation of Baldessari's work, see Coosje van Bruggen, *John Baldessari* (New York, 1990).

56. Kosuth has written extensively about the ideas that lie behind his artistic thinking. His written work is most readily available in *Art After Philosophy and After: Collected Writings, 1966–1990* (Cambridge, Mass., 1991).

57. Bochner 1986, 10; Bochner appended a criticism to this role of conceptualism: "But in so doing, Conceptualism also revealed that the way in which the question is put predicts the answer."

58. From a conversation with Robert C. Morgan in Franz 1986, 92–93; quoted in Bielefeld 1987, 54.

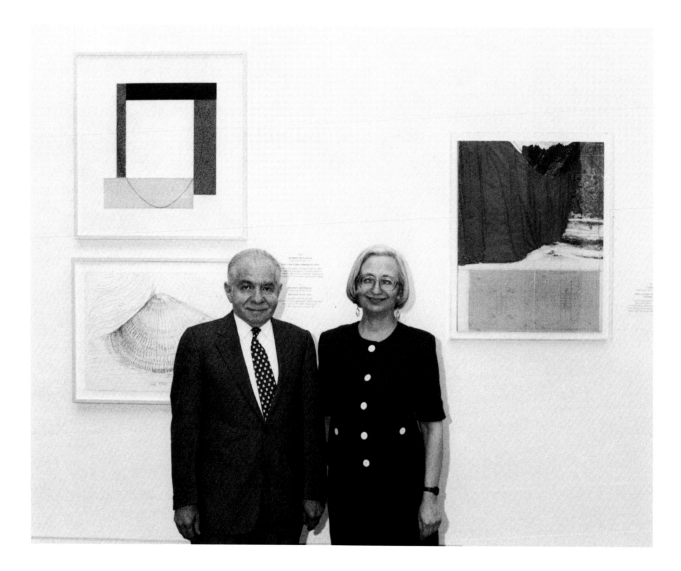

Ruth E. Fine

RUTH FINE: Would you start, please, by briefly recounting the early years of your lives as collectors? How did you meet and become interested in art?

DOROTHY VOGEL: I didn't know anything about art when I met Herby. I came to New York as a librarian, and I was working for the Brooklyn Public Library. Early on I went to a resort in the Poconos, Tamiment, for a couple of weeks in the summer. That fall, there was a reunion of people who attended over the years, so I went to the reunion at the Stadtler-Hilton Hotel. Herby had never been to the resort, but he had heard about the reunion, and I guess he was interested in meeting people; and that's where we met. It was a dance, but he doesn't dance, so we just talked. I thought he was very cute, and he was very, very friendly, very warm.

RF: Dorothy, you grew up in Elmira?

DV: Yes, I went to school there, and I went to the University of Buffalo, where I met friends who were interested in music, and I developed a big interest in classical music. When I switched to Syracuse University two years later I took courses in music, in Beethoven. I had no interest in art at all. Oddly enough, though I didn't know anything about art, I borrowed a reproduction of a Kandinsky abstract from the library's art and music department. Looking upon it later I think it was a very sophisticated reproduction to have selected. It was a late Kandinsky, and I also rented a Chagall, and then when I met Herby. . . .

RF: Which was 1961?

DV: November 6, 1960, at 2:30 in the afternoon. I keep track of things like that.

RF: And you got engaged in 1961 and married in 1962?

DV: Yes.

RF: And your engagement present?

DV: Was a Picasso vase.

RF: Was it a surprise?

55

This is an edited composite of two conversations between the Vogels and Ruth Fine that took place 8 November 1993 in Washington and 11 January 1994 in New York. Galleries and museums mentioned are located in New York unless otherwise specified.

DV: Oh no, we thought it would be nice for Herby to give me a work of art. We selected it together.

RF: So Herb, can we backtrack? Tell us about your work as a painter before you met Dorothy, and how you became interested in art?

HERBERT VOGEL: Well, Ruth, my family was not interested in art because they had to survive. In those days, most people didn't have leisure time; but I had some time, and I got interested in art. I really can't remember precisely how it happened, but I took courses at the Institute of Fine Arts in New York when Panofsky and Friedländer were there. In those days they didn't have contemporary art at the institute. I mean that was forbidden. The only one that came close to contemporary art was Robert Goldwater, the husband of Louise Bourgeois. It was a very nice introduction going there. I didn't realize at that time how great the professors really were, although I used to like listening to them. For example, Panofsky had ways of beautifully juxtaposing ideas and words.

RF: So you grew up in New York, and you were doing art history courses before you did painting?

HV: Yes. And I used to go to the museums, and then I went to the Cedar Bar and met some of the people.

RF: How did you know the Cedar Bar was a meeting place for artists during the fifties?

HV: I can't recall that, but I do know I met a lot of people. I knew David Smith, and I knew Franz Kline and other people. We used to go to parties and artists' lofts, and we went to Provincetown a couple of times. It was the abstract expressionist group that I met in those days. There was no Pop or minimal art at that point. I met Sol LeWitt early on, although I didn't know exactly what Sol was doing.

RF: You met him in the 1950s, didn't you?

HV: Yes, I did.

RF: And were you friendly?

HV: Yes, very friendly.

DV: There's one point that Herby didn't mention. He loves animals. He had an interest in nature before art, and he still has the interest in nature. Somehow I think the nature interest also led to the art.

HV: I think there was a kind of continuity. I wouldn't exclude that. Well, I think Dorothy brings up a very good point because I do feel that there is aesthetic to nature if you can see it that way.

RF: When you started painting were you an abstract painter or were you painting from nature?

HV: I was always an abstract painter. I never painted from nature.

RF: To move on in time, you got married in 1962. Then what?

DV: He was painting, so we put all his work on the wall, but he didn't like to admit to people that they were his.

RF: You started painting then as well, didn't you, Dorothy?

DV: Yes. Because he was so interested in art. Slowly he started telling me about art, and when we got married we came on our honeymoon to Washington. We'd never been to the Metropolitan Museum [of Art] on dates, so the first exposure I really had was at the National Gallery of Art. We did other galleries in Washington, too, but the first one was the National Gallery. There was only the West Building in those days, and we spent several days just going through the galleries. I remember to this day, that I got my first education at the National Gallery.

RF: Did you have favorite paintings?

DV: I guess I've always favored the impressionists. But we came back to New York, and I took some courses in drawing at N.Y.U. [New York University]. This is where Herby was studying painting in the evenings. Then I took painting and I really enjoyed it. I was doing hard-edge paintings, and I think I was pretty good.

HV: I think Dorothy was a better painter than I was.

DV: But I didn't like to give up the time. I worked all day, and to go into the studio at night and on Sundays was too hard. I had a lot of ideas, but I just didn't want to give up the time, and a real artist is dedicated. You make the time. That's the most important thing in your life, but I learned so much by painting that I don't ever regret doing it.

RF: Your first joint purchase was a John Chamberlain sculpture. How did that come about?

DV: Oh, Herby knew John Chamberlain, so we called him up and said we'd like to come down. We got married in January; we went to his studio in February. And that's where we bought our first piece together.

RF: That was 1962, and your first Sol LeWitt purchase was 1965. What happened between the Chamberlain and the LeWitt purchases?

DV: I can't remember. People have asked that question before. But I can tell what was *right* before the Sol LeWitt. We went to the Stable Gallery for the first show of Will Insley. And there was a small, irregularly shaped painting, like a star with a hole in the middle. And we responded very strongly to it. It was one of the first minimal works we saw, and we bought it. We also had seen some minimal art at the Green Gallery as well.

At that same time we went to Leo Castelli's gallery, and ran into Sol LeWitt, and Sol said he was going to have his show at the Daniels Gallery and asked if we would go and see it. In those days there weren't that many galleries, so when we heard about a new gallery we weren't going to wait until Sol's show to go. We went right down to this new gallery, and that's where we met Dan Graham. He was managing the Daniels Gallery, and he showed us some work and we started talking to him. We said we did buy art and that we'd just bought a painting. I described the painting and from the description he knew not only the artist, Will Insley, he knew the exact painting we were talking about. Of course when Sol had his show, we went to the gallery and we liked the show, but we didn't buy anything at the time.

We developed this strong relationship with Dan Graham. He'd come over at least a couple of times a month and talk about art, and I really think these conversations were very important to stimulating us to continue buying minimal art because he was really very knowledgeable. He knew a lot of the artists and we were sort of leaning that way anyhow, and we were encouraged by him.

RF: Do you remember what initially attracted you to minimal and conceptual art?

DV: To us it was challenging but it wasn't that revolutionary. It evolved from what was before. It was rejecting the abstract expressionists, but it made sense. There were Duchamp and John Cage, and other people.

HV: The work might have been right, but the people weren't ready for that kind of work. So it was revolutionary for many, many people, which very often happens when something does break convention or tradition. Later on, if it is very, very good, it will be picked up by history. The whole thing started with Dan Graham who was a big influence, and Sol. Of course, both of them became well-known artists.

DV: At the time Dan was a dealer and a writer. Sol was always an artist, but Sol was also a collector and was always very open to new ideas. He's always bought artists that were unknown. Dan was very intellectual and he had brilliant ideas. So knowing these two people and talking to them put us in a framework to be able to accept what was going on and to be able to absorb it, to be able to understand it. Not that they sat down and taught us, but just being with them and talking to them.

We had two jobs, so we had a little extra money. It wasn't a lot, but you needed some. And I think we stimulated each other. We really had in mind that we would buy art. We didn't know that we would have a collection like we do now. So, I think we were in the right place at the right time with

the right information and we took advantage of it. We had already bought that Will Insley. Dan didn't say go out and buy this or buy that. Just by talking to him and discussing the ideas and the philosophy and even gossip, all of these things were very strong influences on us.

HV: We knew it was different from abstract expressionism, but we didn't realize the implications.

DV: We didn't know it was going to be that important, but we knew it was a new movement and we responded to it. We almost bought an Andy Warhol painting of an airmail stamp. It was at the Martha Jackson Gallery and we had never heard of Andy Warhol then, in 1962. It was very low in price, and Herby said he'd pay cash and we'd be back around Thanksgiving. But my family came in, and we didn't get back to the gallery and when we finally did, it was already sold to someone else.

HV: So we learned early you've got to get something when you see it. If you want it, you get it.

DV: We learned early if there are two and you can't make up your mind, you get both.

RF: Between 1962 and 1965 were you going to galleries on Saturdays often?

DV: Oh yes, but we were also painting ourselves, and I think all the paintings on our walls were our own work. I had one wall and Herby had another wall. Slowly we started to take down our own work and put up the work of other artists. We decided we were better at collecting when we noticed that all these other artists were doing much more exciting work than we were. So we gave it up.

RF: Sol LeWitt is usually credited as the main influence on your collecting. I didn't realize how close you also were to Dan Graham at the very start.

DV: Yes, well, Sol definitely was an influence, too, because we'd go down to Sol's studio at least once a month, and Sol introduced us to a lot of artists, like Carl Andre. We saw his work for the first time at the Jewish Museum, in the *Primary Structures* show [27 April–12 June 1966]. We liked it right away. I think it was quite controversial for its time. The first Andre piece we got was *Four Bent Pipe Run* [1969], from some benefit. We have this modeling clay block piece in the collection [*Clay Coffer Run*, 1970]. We bought it from the Dwan Gallery, and the price was based on the buyer's salary. Carl was interested in art for the people. So we did very well. That's why we got a big piece. The drawing that is in this show, *Limbs* [cat. 2], also was in one of his shows at the Dwan Gallery. I liked it immediately. They said MoMA [The Museum of Modern Art] was considering it for purchase, but that if they didn't get it

they'd let us know. Six months went by, and then we got a call so we ran right down and got it.

Also, Sol's own collection was very influential because he had a lot of the same people we were interested in, and we'd see work at his place, and then we'd want to go down to the studios and see the artists.

HV: I think what Dorothy said is true. Not only is Sol's work important to us; Sol's collection certainly has been a formidable influence in our lives and how we collected. His own collection of ideas and art works helped us enormously in those early days: the formation. You know, I didn't think of it as a formation then, but it slowly or gradually built up that way.

DV: Sol was very good at encouraging young artists in general. He was always very supportive.

HV: He still is. Sol has been extremely generous to us. He's not the only one, but he has continued to be so, including that most recent wall drawing [cat. 52].

RF: Who are some of the other artists, besides Carl Andre, that you met through Sol in the early years?

DV: Lawrence Weiner. Sol sent us to the "January Show" [*January 5–31, 1969*] that was organized by Seth Siegelaub. He rented space somewhere in the 50s [1100 Madison Avenue, New York] and had four artists: Bob Barry, Douglas Huebler, Joseph Kosuth, and Larry Weiner. There was a catalogue for the show, and when Seth gave it to us he said this is going to be very important later on, and he was right. Actually that's where we first saw the work of all four artists. The piece that we actually bought from Larry at that time was *Structure Poem* [cat. 88]. His sentence fragment [cat. 89] has sort of been our signature piece. I've given a lecture in Holland using its wording [MANY THINGS PLACED HERE & THERE] as the title. We always have it up in the bathroom. We've had it in many shows.

HV: The Seth Siegelaub show was the innovative show in this country for conceptual art at that point, the first of its kind.

DV: It's interesting. There are three pivotal shows when you reflect on it. The pivotal conceptual show was the "January Show"; the pivotal minimal show was the *Primary Structures* show at the Jewish Museum, and then there was *Amsterdam, Paris, Düsseldorf* [6 October–26 November 1972] at the Guggenheim [Solomon R. Guggenheim Museum]. If I'd pick three shows that had the most influence on us, I'd pick those three.

HV: These shows were done at a time of birth of the movements.

DV: Between Sol and Dan we also met Bob Mangold, Sylvia Mangold, and of course, Bob Smithson, although we never got our Smithsons from Smithson. We got the two Smithsons we have from different benefits I think. Sol brought Jan

Dibbets over, and he had with him *Perspective Correction* [cat. 35]. He came back a few years later and we bought two working drawings [see cat. 36]. There aren't many of his working drawings in this country.

HV: Not of that period.

DV: And when we visited Holland around 1980, we looked up Jan Dibbets. We went to his home for dinner; he took us to the Kröller-Müller Museum [Otterlo], which is a distance away; arranged for us to go to Eindhoven and meet with Rudi Fuchs [then director of the Stedelijk Van Abbe Museum, Bilderdijklann] and Martin Visser [then curator at the Boymens van Beuynigen Museum, Rotterdam]. He was wonderful.

Dan introduced us to Mel Bochner. But we really don't know him very well, and we got his drawing [cat. 23] from the Sonnabend Gallery. Through Naomi Spector and Steve Antonakos we met Richard Artschwager, right about the time 420 [a gallery building at 420 West Broadway] opened, in September 1971. In the seventies we used to go to his studio very frequently. In the early days we went to Dennis Oppenheim's studio a number of times too.

RF: It always has been important to you to buy from the artists directly. Would you talk about how knowing the artists has played a part in the way you developed the collection?

DV: I think knowing the artists adds another dimension because you get to really know the work a lot better. You understand it better, and you see things through their eyes. I learned more just by walking around the [Robert] Ryman show [at MoMA] with Richard Tuttle than I ever knew about Ryman before. Just looking at the show with another artist, especially Richard, I saw things for the first time. So, knowing the artists not only enriches their own work, but has helped me to see other artists' works as well. It's very exciting to know the artists. Their thinking is more liberal. They're very open people. Of course, they're as varied as other people. I'm not putting the artists high on a pedestal, but they certainly live more interesting lives than a lot of other people.

We used to have long philosophical talks about art with On Kawara. He sent us the postcards [cat. 46] and telegrams. Any place he went, he'd write down the people he saw.

HV: On Kawara is a very significant artist among these early conceptualists because later on, in the seventies and eighties, he was a prototype for other artists who became autobiographical in their work. But he did it in a conceptual way.

RF: When you would go to a studio to acquire something, if you felt strongly that you wanted something and an artist felt strongly that it would be better for you to have something else, what kind of dialogue would take place?

DV: Generally, we only go to studios if we know the artist's work to begin with. We'd see it at another studio or at a gallery. We never go just because someone says "Go down to the studio, and see. . . ." It doesn't work that way. We'd know the work, and we'd like it, and then we'd talk to the artist and they'd show us a range. Sometimes, it takes a long time of narrowing it down and narrowing it down and making choices and working with the artist. "Why do you like this one better?" "Why do you like that one?" "This is more characteristic." "Oh, I love those colors." "Oh, the proportions are so great." You know, it's a lot of hard work. It's not just going to the studio, saying "Oh, that's what we want, and that's it." It can take a long, long time; and this comes with the knowledge of the artist's work to begin with and then working with the artist and hearing what he or she has to say. Sometimes they say, "Well, this is my favorite," and sometimes you don't necessarily like what their favorite is. Their reason for a favorite might have nothing to do with the work. It might have to do with what they were thinking of when they were doing it or something like that.

Other things happen when you know the artists, too. For example, we got our first Joseph Kosuth, *Art as Idea: Normal* [cat. 47], from Dan Graham. When we met Joseph he said we didn't have the complete piece because we didn't have the tear sheet, where the definition came from. So we got that from him. Later on we bought *Art as Idea: Nothing* [cat. 48] from him. He had a whole show of "nothing," which were the different definitions from the different dictionaries.

Herby and I sometimes would have different opinions. It turned out that I was better at selecting Sol LeWitts.

HV: Yes . . . still is.

DV: And Herby was better at selecting, say, Lynda Benglis. He picked up on the flamboyant artists, and I leaned toward the more minimal.

RF: Has that remained true over the years?

HV: I think so. Dorothy was very, very good, as she said, with Sol LeWitt, and I never really felt any conflict with her choices. I'm more intuitive and Dorothy is much more cerebral or intellectual. I just want to say that I kind of think in those days, the early days when you had fewer galleries, you had artists who really cared who they showed with. There were not enormous sales, and I think there's a very big difference between the fifties and sixties, as opposed to the nineties, when the artist is almost lost within the galleries because they're showing in so many places simultaneously, and their attitudes are completely different than I remember them twenty-five years ago. There are

some artists who care about where their work is shown and with whom, but it's a whole different concept. I don't know which is better. I'm only making a description.

DV: Well, I think it's much more competitive now.

RF: Which were the galleries that you went to most frequently?

DV: One very influential one was the Bykert Gallery that was run by Klaus Kertess. In fact many of the things that are in our show came from his gallery.

HV: Early Brice [Marden]; Chuck Close—we were one of the first to buy him in those days. We bought from Dorothea Rockburne's first show at the Bykert Gallery. I feel very good about it, Ruth, because I think there's a sense of history, rather than just purchase. I came out of art history training, so I guess I'm old-fashioned.

DV: We saw Alan Saret's work at Bykert, and Klaus gave us his phone number and told us to go down to his studio ourselves. The two-part piece [cat. 79] was made for our Clocktower show [the exhibition center of the Institute for Art and Urban Resources, New York], so it was made for us for that particular situation.

HV: In those days, scatter was related to minimal. That's when installations first came out, innovatively, with that kind of media.

DV: It seems interesting how so many things go back to the Bykert Gallery. Of course, since this exhibition is minimal/conceptual — a lot of the friends we have now are not minimal/conceptual—we're talking about relationships we had twenty-five or thirty years ago. We're not talking about a lot of the people we're close with now.

RF: What about other galleries?

DV: I think it's exciting to know some of these dealers. We knew Betty Parsons.

RF: You have a piece by Betty Parsons.

DV: Yes, which she gave to us. I consider her a legend.

RF: What about Leo Castelli?

DV: We got our Judd sculpture [cat. 44] from his first show at Castelli. He was still pretty unknown at the time, so he came over and put it up for us.

HV: The sculpture is a unique piece. It is not one of an edition. In those days he was just doing one.

DV: We got a drawing from him, on yellow paper [*Drawing for "Untitled,"* 1966–1968]. It was on the cover of his catalogue at the Whitney [*Don Judd*, Whitney Museum of American Art, 27 February–24 March 1968]. And we got the red piece [cat. 45] from John Coplans.

We saw Robert Morris' work for the first time in the Jewish Museum show, and we got some drawings from Leo Castelli. When the $100 Gallery opened we got the quadrant piece [*$100 worth of a larger more expensive drawing*, 1977] from them.

RF: Tell us more about the $100 Gallery.

DV: That opened up, I think, in the late seventies. We were the first customers. We got some Carl Andres, some Sol LeWitts, Robert Morris, Lawrence Weiner. Actually we were the last customers too. It was open three or four years, downtown, near the water. Poppy Johnson ran it.

HV: Oh, we got the Dan Flavin [cat. 37] from Jill Kornblee. That's one he did himself.

RF: To shift the subject, we've talked a bit about Sol LeWitt. There are a number of other artists who are also very important in terms of the numbers of works you have by them in your collection. One would be Robert Barry. Does one or the other of you have a stronger sense in selecting the Robert Barrys? And how did you come to know him?

HV: No, I think we're both strong on that one.

DV: Well he was a conceptual artist, and we were sort of in the same circles. Every time he would see Bob Barry, Herby would say, "When can I come down to your studio?" At the time, Bob was teaching. And so selling wasn't really a concern of his. He didn't feel he had to sell, and he was with a good gallery, Leo Castelli. But Herby kept asking him, and finally his wife Julie said, "Why don't you have them come down? They've been asking for so many years." So he broke down and around 1974, something like that, we went down to his studio. He lived in New Jersey, and we bought *Art Work*, 1970, a sheet he took from a catalogue.

RF: Oh right, he took it out and signed it. I know the piece.

DV: Yes, that's the first one. And I think that same visit we bought the *Closed Gallery* piece [cat. 12]. The reason that piece was never sold before was because Bob didn't know how to sell it. How can you buy a *Closed Gallery* piece?

RF: It wasn't mounted when you got it?

DV: No. Herby knew of the piece and he thought it was very, very important. So Bob thought we could take the documentation, the announcements for the three shows when the gallery would be closed, and frame them. So we did. And that's the *Closed Gallery* piece.

HV: Which in my opinion is one of the most important conceptual pieces.

DV: Even the ownership was conceptual because anybody having those three announcements could frame them and say there's the *Closed Gallery* piece. But

we have a piece of paper that says we own it and Bob has a piece of paper that says we own it. One time we had it traveling in one of our shows and someone wanted it for a show in Germany. So Bob took other copies of those announcements and sent them to Germany. So there might be two *Closed Gallery* pieces around, but we own it. We see Bob and talk to him very often, and he has made many things just for us.

RF: What about Edda Renouf? You have a very large selection of her work.

DV: We got it all from her. We met her through Richard Tuttle. She was living in Paris at the time, but I think Richard introduced her to us at Leo Castelli's. Then we went on to Ronald Feldman's and they were there. We were buying the Beuys drawings, and she was able to look at them and to translate the German. She knows French, German, Spanish, and we were very impressed with that. When she came to New York again she looked us up and we went to galleries together. Then she started bringing her work with her and we'd buy it . . . drawings, paintings. Then in 1975, I think, she moved to New York, and got a loft on East 30th Street. Before that we saw her twice or three times a year. In New York we became very close, and we got to know her father, who's an artist, and her mother.

Edda Renouf told us about André Cadere, and we were very intrigued. He lived in Paris, and he'd go to all these art events carrying a stick wherever he went. He was quite well-known in Europe. I met him at an opening—Herby wasn't there—but he was only in this country for a short time and we were busy. So we couldn't get together with him at that time, but we got his address and started to write to him. When he came to New York again we went out to dinner and then we bought the piece that he carried around in New York [cat. 27].

HV: I think he's a very interesting artist for the period because, in my opinion, he bridges performance and installation, which were very significant in those days, and conceptual. And I like that idea.

RF: What about the other arts, performance, especially given your early interest in music, Dorothy? Do the two of you go to the ballet, to concerts?

DV: We used to go to ballet a lot. But then it got expensive and also we got so involved with the art world that I didn't want to have to decide whether to go to the ballet or to an opening at the Museum of Modern Art. We rarely go to concerts. We used to go to Phil Glass concerts when they were in lofts and galleries.

HV: I remember that we did go to performances a lot early on. I thought that, intertwined with conceptual and minimal, was part and parcel of the period.

DV: We saw Vito Acconci do a performance of the *Step Piece* [cat. 1]. I don't

remember how we met, through Dan Graham is my guess; but we were the first to buy his work. Also, we went to a few "Happenings" when Alan Kaprow was still in New York. Now performance art is much more political. In those days it may have been political, but that didn't dominate.

RF: Did you know John Cage?

DV: We got our Cage drawings [cats. 28, 29] from Carl Solway. We met him when we had our show in Cincinnati [at the Contemporary Arts Center, 17 December 1975–15 February 1976]. He had a gallery there. But he also had a gallery in SoHo, and we used to go down there frequently. That's where we got the Merce Cunningham drawing as well [cat. 33].

The only time we ever really had a long talk with John Cage was at an opening in Buffalo. I think it was Carl Andre's opening at the Albright-Knox [Art Gallery, Buffalo, N.Y.]. Everybody went in to eat but us because they had pork or ham, which we don't eat and Cage was on this macrobiotic diet. We had him all to ourselves. That was our one great visit with him.

HV: We talked to him a few times after that as well.

RF: Who are some other artists you feel personally close to?

DV: In those days, we were very close to Ruth Vollmer. Ruth was older than we were, but she'd shown with Betty Parsons. She was very close to Sol LeWitt.

HV: She was also very close to Eva Hesse . . . almost like a mother to her.

DV: Yes . . . we became close to Ruth after Eva died.

RF: And you bought your Eva Hesse drawing [cat. 42] after she died as well, didn't you?

HV: We never bought anything from her when she was alive. Which was a great mistake. We knew how good she was, but somehow you miss.

DV: A lot of her work was too fragile, we thought, with all of our cats. Anyway, we were very close to Ruth. She also was close to Tuttle, so Ruth sort of bridged a lot of our friends together. She was friendly with the Mangolds too.

HV: It was like going to a Gertrude Stein salon. Every evening we went there she welcomed you in a very warm manner, and she'd always have interesting people. Museum people, artists. There's no one I have met since who was able to put people together the way Ruth did. And when she opened that door you knew you were invited. She was unique in that sense, and I thought that was beautiful.

RF: About two-thirds of your collection is composed of drawings; and as this exhibition makes clear, one very strong thrust of the collection is conceptual and minimal art, art in which the idea is primary. A drawing often is the place where an idea takes its form in the most basic sense. Do you think about that

66

as collectors? What fed your decision to emphasize drawings?

DV: I don't know. We've always liked drawings. It is a very personal art form. As you said, the ideas are all there. It was also more affordable.

HV: And usually, in those days, drawings were small in size, not gigantic painting size. I mean, drawings are competing with paintings today. You had drawings in the Renaissance that were cartoons for paintings, but they really weren't shown the way drawings are today.

DV: A lot of drawings are done by the artist's own hand while a lot of other work is fabricated.

RF: You have a number of drawings by sculptors, which suggest the real power of sculpture.

DV: Yes. You know, it would be very hard for us to have a large sculpture, but drawings give you the power in a small form.

HV: I like your word "power" because it's true that you can get similar power in a good drawing.

DV: And you don't get it in a scale model. It's very hard to do a small model of a painting or a sculpture, isn't it, and get that feeling of strength.

RF: There is often something intimate and unshowy about drawings as well.

HV: Not anymore.

67

RF: Well yes, there still is. Not with everybody, of course.

HV: Do you think they're personal if they're seven feet high?

DV: But not many drawings are that big.

RF: And I'm talking about the drawings in your collection. But regardless of size, there's often a sense of the handling of materials, another of the qualities I associate with drawing. I don't think size diminishes that feeling of it being made.

HV: I agree with everything you said about materials, but if something is *very, very* large, I wonder how personal that remains.

RF: Both a sculpture and a drawing by Richard Nonas are in the exhibition [cats. 63, 64].

DV: We saw his work for the first time at 112 Greene Street. That was an alternative space. I guess it still is some kind of exhibition space. They did a lot of great group shows. We thought Nonas' work was very strong and used to go down to his studio often.

HV: I like the rugged, industrial way he worked, which I thought certainly coincided with the minimal.

RF: Let's take a real shift in direction. The first exhibitions from your collection were those at the Clocktower in New York and the Institute of Contemporary Art in Philadelphia, in 1975–1976. When you started you

weren't thinking about making a collection, but at a certain point you became aware that you had a collection. I'd like you to talk about how that happened, when it happened, what these early exhibitions meant to your understanding of what you'd done as collectors.

DV: We didn't call it a collection until other people did. People started asking to come over and see "the collection," and that's when we realized that it existed. We were told that people were talking about us and were curious and wanted to see our art; and that's how that happened.

RF: When did that start?

DV: I'd say probably in the early seventies.

RF: Can you remember who some of the first people were?

DV: I think Bob Grosvenor was one of the first to say that.

RF: How did you come to know his work?

DV: We saw it for the first time at the Jewish Museum in the *Primary Structures* show, where we saw Andre for the first time. By then we already had Sol LeWitt in the collection.

RF: So the first people who were talking about the collection were the artists.

DV: Yes; and then different museum people starting coming, first from Europe.

HV: In those days a lot of people were very, very interested because not a lot of people were collecting what we collected, and the Europeans were quite early with their interest in minimal and conceptual art.

DV: We had a lot of Dutch people, German people, Belgian. . . .

HV: All the time.

DV: And one would tell the other, and we'd get a call, "I'm so-and-so's friend. Can I come and see your collection?" One summer we had a few curators from the Stedelijk Museum in Holland, and I thought it was funny because here people are going to Holland to see the Stedelijk and the curators were coming to see us. But we enjoyed meeting these people, and when the Museum of Modern Art opened its new wing, which was much later, we were invited to a luncheon that was really for curators. Everybody was there . . . museum people from all over the world, and we sat at a table with people from Finland, from Sweden, from Switzerland, from Holland. Just about everybody at that table came over to visit us that week.

RF: And so the 1975 Clocktower show was a big event.

HV: Sure was in those days.

DV: Alanna Heiss was the originator of the Clocktower . . . and she's the one that formed P.S. 1 [an exhibition space in Long Island City]. She wanted us to show the collection at the Clocktower, and at first Herby said "No," because they

could not do a catalogue and we were concerned about the security. This was in an office building on the top floor. We were very protective of our things. So Alanna opened her first show, I think it might have been Joel Shapiro.

HV: I think it was. . . .

DV: And then she had a show of Richard Tuttle's paper pieces and she ended her first season with James Bishop. We had met Bishop at an opening of one of Richard's shows. Then we saw a show of Bishop's at the Fischbach Gallery, but we didn't understand his work until he had the Clocktower show under the right light. Then we saw it really for the first time. It shows you that the lighting is so important.

Anyway, the second season at the Clocktower, I think Alanna showed Nonas . . . I don't remember exactly, but we were finally convinced that if she hired guards and if some kind of pamphlet or checklist could be published, we would do it. So, that's how that happened, and it turned out to be forty-one artists I think, one work by each artist.

RF: Did you choose it or did Alanna Heiss?

HV: We never choose any show that is formed. We're not curators.

DV: We might have made suggestions. At about the same time, friends from Philadelphia, the Bruttons, came to our apartment, and they said that Suzanne Delahanty [then director of the Institute of Contemporary Art, Philadelphia] should see our collection. So they brought her over, and she said she wanted to give us a show. Suzanne's show had two hundred works, and it traveled to Cincinnati. So the first show was the Clocktower, and the first big show was the Philadelphia show.

RF: When I first came to see the collection, it was fairly difficult to see.

HV: You couldn't see it at all, Ruth.

RF: Because it had grown to such proportions, and totally filled your apartment. Can you give me some sense of when it took over the way it did?

DV: Well, we would buy drawings, and drawings don't take up much space. But then we'd have these shows and the drawings would get framed, and then the shows came back. I think after Philadelphia there wasn't too much of a problem. But after the University of Michigan [11 November 1977–1 January 1978], they came back in these crates and we didn't have any room to put the works anyplace. The closets were full, so we just kept the crates in the living room and the works in the crates, and from there on as each show came back, we just kept the crates, and they became the base for all the work piled on top of them.

RF: It was amazing, a mythic space. It seems like looking at art and collecting art became the basis of your life.

69

HV: I guess so. I will say it's been a great pleasure to put the collection together. And when we did it, we didn't realize we were doing it. We were doing it just for the joy. And I think we still get a great deal of joy, and we are very, very happy to share it with people. That's how I feel about it, and when I say "I," I mean "we."

RF: Let's talk about Richard Tuttle. You met him around 1969 or 1970, didn't you? Did you meet him at an opening?

DV: Well, we first saw his work at Betty Parsons' gallery. I don't remember seeing his early, early shows: the wood and the tin. But we saw the cloth show and those pieces were really knockouts; but they were so innovative, and we just were taken by surprise. We didn't buy from that first show, but we thought about it. One night Jock Truman, who was the director at Betty Parsons, came over for dinner and he said that Richard's next show was going to be paper and he was going to do a very affordable piece. It was going to be a multiple, so that people who couldn't afford some of his more expensive cloth pieces, could buy something by him. So the show came and sure enough there was this paper octagonal that was wallpapered on the wall, and he was going to make up to a hundred. Herby always liked unique things, one of a kind, and the idea of getting a multiple was not something that Herby would do, but I said that I wanted it anyhow. Jock said that if we called Richard, he would put it up for us, so one night Richard came over with all the tools you need to wallpaper something.

HV: Which wasn't very much.

DV: Well . . . paste, paper . . . I don't know. He brought it with him, and we showed him where we wanted it, and he put it up. Richard seemed very friendly, very nice. We liked him, and so Herby said to him, "Can we come down to your studio sometime?" And he said, "Sure." So shortly after, we went down on a Sunday afternoon. We selected some drawings, and after we made our selection and we paid for them, Richard said, "Let's go and have something to eat." So we went to this Greek restaurant in the 40s and it became a social thing too because we liked talking to him. He is a brilliant person. We built up this friendship of going to his studio and looking at drawings, and the only reason we ever got out to eat anything was because Richard himself got hungry for supper. We could have stayed on forever.

HV: I don't know about that, but. . . .

DV: It's funny, when he was in town last week, after we met at the Museum of Modern Art to do the Ryman show together, we got something to eat, and then it was late, 9:30, 10 o'clock at night, and Herby said, "I really want to

come down to your studio." So we went down by cab and we stayed almost 'til midnight looking at work. It was just like old times.

HV: You know, it's a unique situation, Ruth, the way these things fall out, where you get not only a work of art or works of art, but you get something very special, which I can't define.

DV: I just wanted to say that at the panel discussion in Indianapolis [at the time of Tuttle's 1993 exhibition at the Indianapolis Museum of Art], I said that first meeting changed our lives and Richard said, "Changed mine too." I was very touched when he said that. And we met a lot of people through Richard Tuttle, actually.

HV: One artist will usually introduce another artist and in those days it was much more closely knit and I keep reinforcing that because I miss that. I mean in those days, everybody knew each other. I never knew it would be any other way.

RF: So you must have good memories of when Paula Cooper opened downtown in about 1968. I mean that was a whole new situation.

HV: Oh, of course.

DV: I remember I got lost the first time because Herby was waiting at Prince Street, and I was waiting at Spring Street. One of those things . . . we were both waiting at the wrong subway station because we were not used to going down to that area. We bought our Jonathan Borofskys [cats. 24, 25] from Paula Cooper.

HV: They're early.

DV: He was supposed to number them but he never did. We also saw Joel Shapiro's work at Paula Cooper's first. She had a show of drawings and we got a fingerprint drawing. One time we went to Joel's studio and it happened to be my birthday. We already had some of the sculpture that we got from him. When he learned it was my birthday he gave me a piece.

HV: Those little pieces from that period, if they carry the space, are dynamite. They had the minimal, the installational.

RF: Are there any other anecdotal stories that would convey the kind of warm relationships you have with many of the artists in this exhibition?

DV: Well, a big event was when I turned fifty years old. Diane Brown gave me a party at her gallery. A lot of the artists were there. And then when I retired three years ago, Carroll and Donna Janis gave me a big party, and a lot of the artists were there. Jack Cowart [deputy director and chief curator, The Corcoran Gallery of Art; formerly curator of twentieth-century art at the National Gallery when the Vogel collection was acquired] was there, and I guess we started to seriously consider the National Gallery shortly after. That

71

was very exciting. You know what, I keep forgetting one segment in the whole story. It was our twenty-fifth wedding anniversary, and we wanted to do something special and a coworker said, "Well, why don't you go to Washington?" He knew we went there on our honeymoon. We're not really big travelers unless it was for a certain event, but since we came to Washington on our honeymoon. . . . We knew Jack, so I wrote him a note saying we were going to be in Washington and could we see him, and we came to the National Gallery and that's where I met you, and you showed us where all the drawings and prints were stored in those big, black boxes . . . do you remember?

HV: Yes, I remember. That was impressive! I tell you for me it was.

RF: Mostly you've collected work by artists who are based in New York. Is that because that allows you to go to their studios?

DV: Yes. For some of the works in the collection, though, the artists happened to visit New York; Sol LeWitt brought over Jan Dibbets. Klaus Rinke came to New York. We met him when he did a show at the Clocktower, and when we went to Germany when we had our show at Bielefeld [*Beyond the Picture*, Kunsthalle Bielefeld, 3 May–7 July 1987] we looked him up and had a very nice evening with him.

HV: He teaches at that academy [Düsseldorf Academy] where Beuys taught.

DV: He had this big collection of cactus. We heard about Beuys from Richard Tuttle, and we saw his *Coyote Piece* [*I Like America and America Likes Me*] at René Block Gallery [23–25 May 1974]. We went to some of his lectures, and we were introduced to him at an opening. We got the Dieter Roth from René Block too. I'm not sure how we heard about him, but I know we saw that show at the Guggenheim, *Amsterdam, Paris, Düsseldorf,* where we saw a lot of these European artists for the first time. He was in that show; I think he had chocolate pieces. That was one of the shows that turned out to be very important for us; so many of the artists that we have were in it. Hanne Darboven sent her piece to us in the mail [cat. 34]. Baldessari sent us his piece in the mail, too [cat. 11]. We didn't pick it out.

RF: Where did you meet Darboven?

HV: I think maybe at Leo's. I'm not exactly sure, but. . . .

DV: We met Daniel Buren through Larry Weiner. We went to visit Larry and Buren was there. We don't know him well, but we got the piece from him [cat. 26]. We did meet Dieter Roth much later, too. So a lot of the artists who we didn't know at the time we bought their work, we met later.

The Christo story is interesting. We had seen the work and we liked it. I think there was a benefit where they were selling different artists' works

and I think we might have put in a bid for a Christo and we didn't get it, but Herby said, "Maybe if we called him on the phone we can get one that way." He called him and they [Christo and Jeanne-Claude, his wife] had heard of us because we had loaned various works to different museums, so they said to themselves, "The rich collectors are coming over. Now we can pay the rent!" Then we got there and you know, we're not Rockefellers. They can see the way we're dressed who we are. But we developed a friendship anyhow. They love to tell that story.

We got our first Christo piece when they were doing the *Valley Curtain*. They had this cat, Gladys, and they asked if we could take care of Gladys for the summer, and they'd give us a piece. And that's how we got our *Valley Curtain* [cat. 30]. We met Nam June Paik through Christo and we bought our drawings from him [cats. 68, 69].

RF: One of the things we might talk about is how many women artists are represented in the collection.

HV: Oh, they came in early, *very* early.

DV: I always get upset when people come and say to us, "How come you don't have more women artists?" We do have a lot, and I'm glad you realize that.

HV: Now we don't go by gender. We go by what we see and what we like, but we did have a number of women artists in those early days.

RF: The generation that you started collecting was the generation when large numbers of women started actively to make their art more highly visible.

HV: Right, and I remember approximately when that happened. There were a few exceptions, but when women came into having at least a decent share and their reputation and being themselves was right after abstract expressionism. The abstract expressionists held onto that male dominance to a certain degree. There was Helen Frankenthaler and Lee Krasner and a few others. Also, I would like to say something historically about the collection for a moment, and that is we were the second ones to buy Lynda Benglis.

DV: We met her when she worked at the Bykert Gallery. The first piece we got was a latex puddle piece that's not in this show.

HV: We bought Dorothea Rockburne early, Jennifer Bartlett. . . .

DV: We don't know Jennifer well, although we were at her studio very early, years before she was well known. But we got the drawing [cat. 14] from Paula Cooper.

HV: Jo Baer, and a lot of others.

DV: We met Jo Baer through Dan Graham, and she made the diptych [cat. 10] for our living room, for the space that we had. It was there for years and years. We never loaned it out.

DV: We were the first to buy the Bechers [cat. 16] from their first Sonnabend Gallery show.

HV: Well, while we are talking about collecting I'm trying to tie it a little bit historically, not just making it totally personal. I feel that's what makes this collection slightly different is that we were early in many situations that people picked up on later. If you're buying someone early, whether he or she is known or unknown, I think that makes a bigger difference than when you're buying that person later on.

RF: For the artists themselves it's encouraging to have someone buy something.

HV: Exactly. Dorothy and I bought from a personal point of view.

DV: Well, you know people who feel strongly about that are Christo and his wife, Jeanne-Claude. We were visiting them a couple of months ago. They felt that the personal was very, very important. I've never heard an artist say that before. I was quite surprised because artists, when they talk about their work, think that their work is *the* thing. But they thought the personal part of our collection was very important.

RF: You traveled to see the Christo piece in California?

DV: Yes, we saw the *Running Fence* [Sonoma and Marin counties, California]. We saw the *Wrapped Walk Ways* in Kansas City [Missouri], and we saw the *Surrounded Islands* in Florida [Biscayne Bay]. Notice we saw only projects in the United States. We didn't go to Paris for the Pont Neuf [*Pont Neuf Wrapped*].

RF: Hasn't your European travel basically been to see shows of your collection?

DV: No. We got married in 1962. We took a trip to Europe in 1963 for five weeks, and that's where I continued my education, by looking at art in the various museums. And in 1965, we went on another trip to Europe. We went to Spain and other countries, looking at the museums. And that, with the National Gallery and then going to the Metropolitan, formed my background of learning about art. Still to this day, I've never taken a course in art history.

We took a trip to London in 1970 where we met Richard Long. We'd already bought our Richard Long from John Gibson. But Nicholas Logsdail, who owns the Lisson Gallery [London], knew that we had that piece and said that we should meet Richard Long. So we took the fast train from London to Bristol and met him, and he showed us the general area where he did the plucked daisies [*England*, cat. 53].

HV: At that time he wasn't known. Ours is the one that was in *Life* magazine [25 April 1969, 82].

RF: Let's talk about the Mangolds.

HV: Oh yes, that's important of course, both of them.

DV: Well, it's funny how we met Bob Mangold. Actually, Bob was one of the people who helped Sol deliver our first Sol LeWitt piece. We didn't go into that first Sol LeWitt piece; that's another story. We had known Bob's work of course, and I think through Dan Graham we went down to his studio on Eldridge Street. He was getting ready for a show at Fischbach Gallery. All the works were large; and he made scale models that were small. But he made an in-between size for himself. That's the one we wanted to get, and so he sold it to us [*½ W Series (Medium Scale)*]. We went down several months later for another painting. He had another one of that singular size, and so he sold it to us [*½ V Series (Medium Scale)*]. And then the third one, the blue one, was made for us [*½ X Series (Medium Scale)* (cat. 55)]. We went to the studio originally because of Bob, but then we started to see Sylvia's work as well and got to know her. I think we started getting her work when they moved up to the country. We like her work very much too.

HV: We're going to see them next week. Unless something changes. We just added a little gem of a drawing by Bob to the collection. You haven't seen it. Just beautiful. It's nice to continue that kind of relationship.

RF: Yes. I think I should ask to hear the story about your first piece by Sol LeWitt.

DV: Well, the work that he showed at the Daniels Gallery was minimal sculpture in different colors. They were quite innovative and very dramatic, but we didn't buy from that show. But we thought about it. Then in the summertime, we said we should get a piece, so we called Dan Graham and said we wanted a Sol LeWitt piece. He said the gallery was closing and to go see Sol. So we went to Sol's studio, and Sol said there was a piece he thought we might like. We went over and it was this gold piece; we liked it and we bought it. That's the one Bob Mangold helped him deliver. Sol came over several years later and said his work had changed. He was working more minimal then, using a lot of white and black; and he asked if we would mind changing our piece for a current one. He really wanted us to have a more current work, and so, dumb as we are, we said, "Yes." Of course, we should have gotten the new one and kept the old one. I mean, you learn as you go along. Anyhow, there was a sculpture shown at Finch College [now closed, formerly in New York] that we loved, a standing sculpture, narrow and tall. We got that piece at that time [*Standing Open Structure Black*, 1964, now at the Wadsworth Atheneum, Hartford, Conn.], but we couldn't stand it up because it was about eight feet tall. Our ceilings were not much taller and you needed a little leverage to get the piece up; we had it sideways for a while. So Sol said we could change it

and that's how we got the big, black piece [cat. 49]. That's the first large-size modular piece he did.

HV: Among the first.

RF: And he has since actually destroyed the first piece that you traded back.

HV: Yes.

DV: But he did make us a model of the middle one, the Wadsworth Atheneum one.

HV: And a drawing.

RF: I'd like to close our conversation by asking how you feel about being included in the January 1994, "*ARTnews* 200," the list of the world's top collectors?

DV: I feel very proud because we by no means have the economic status as other people on the list; and to be able to do what we did on what we had is a miracle. I'm still amazed. When I saw that list I was tickled pink. To be so recognized is quite an achievement.

HV: Ruth, I am surprised. I'm still surprised.

*System of possible movements trans-
mitted from the body to the environ-
ment: body haunting space. . . .
Locomotion across a boundary (perfor-
mance as pathway from one region to
another): communication through a
boundary (performance as extended
region).[1]*

—Vito Acconci, 1970

78

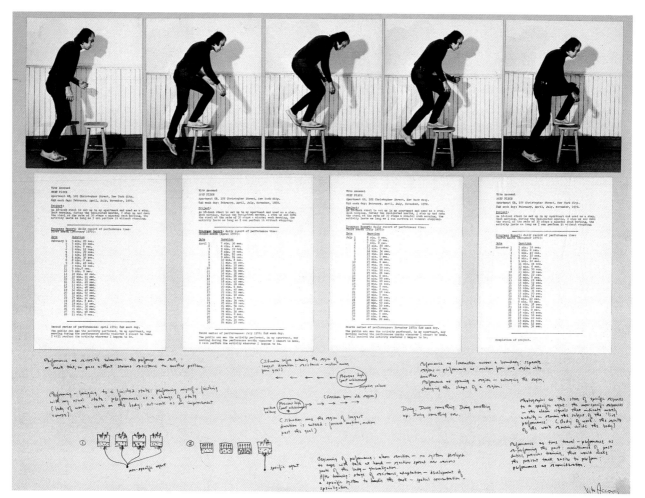

Vito Acconci *Step Piece*, 1970 (cat. 1)

Art is what we do. Culture is what is done to us.[2]

— Carl Andre, 1967

The function of sculpture is to seize and hold space. . . . Rather than cutting into the material, I use the material to cut in space.[3]

— Carl Andre, 1965

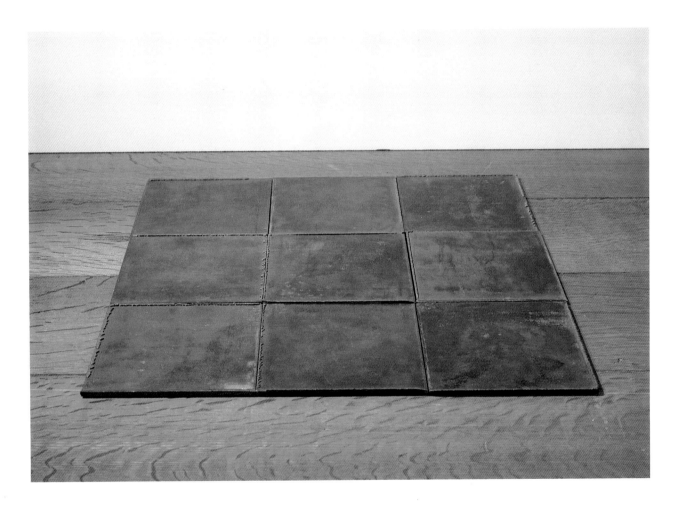

Carl Andre *Nine Steel Rectangles,* 1977 (cat. 4)

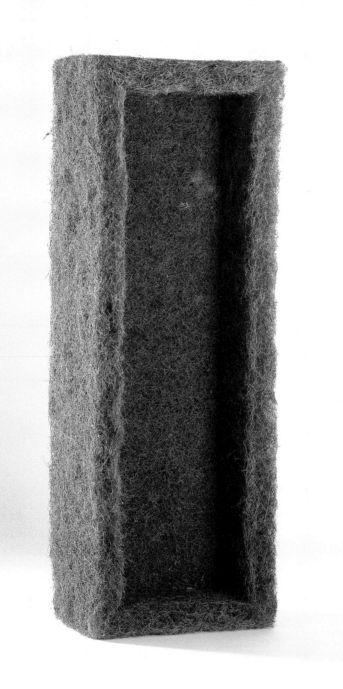

My aim is to imbue my work with qualities of grace, beauty, monumentality, reverence, sense of purpose, sense of the eternal, purity, truth, craftsmanship, significant form, durability, honesty, and strength. . . .

—Richard Artschwager, 1965

80

Richard Artschwager *Hair Sculpture—Shallow Recess Box*, 1969 (cat. 8)

In part my work was congruent with the sculptors', especially in their focus on objecthood, then a primary and timely concern. This act of looking long to the nature of the object and into its specific organization stood for a hard look at integrity and the motions of deceit—an inquiry which further projected a quasi-political, visionary stance.[5]

—Jo Baer, 1983

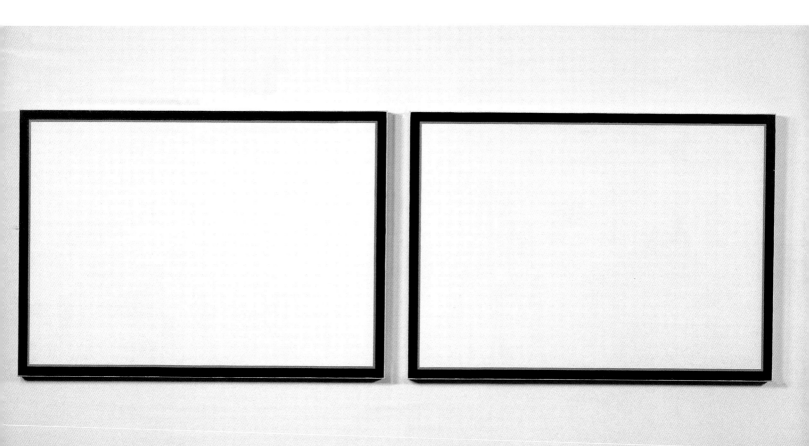

Jo Baer *Untitled*, 1968 (cat. 10)

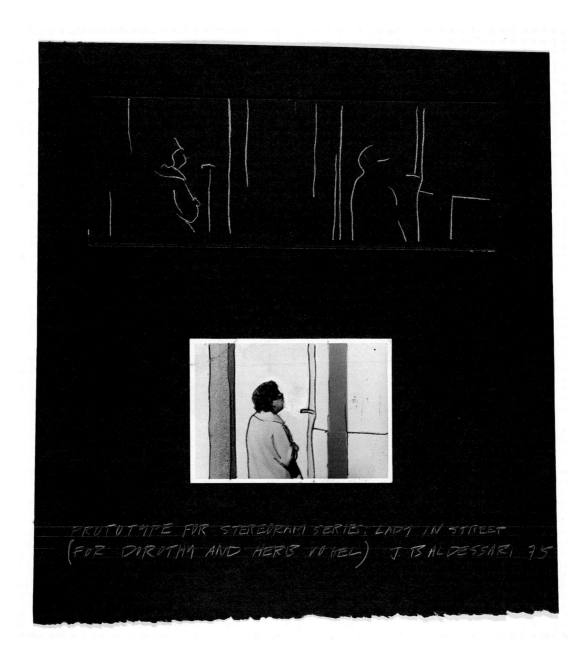

82

John Baldessari *Prototype for Stereogram Series: Lady in Street*, 1975 (cat. 11)

It's implied that their [words] meaning extends beyond their arbitrary boundaries, that they are part of something larger and not just isolated or insular objects, they're part of and influencing the situation and even the culture in which they are encountered.[6]

—**Robert Barry, 1989**

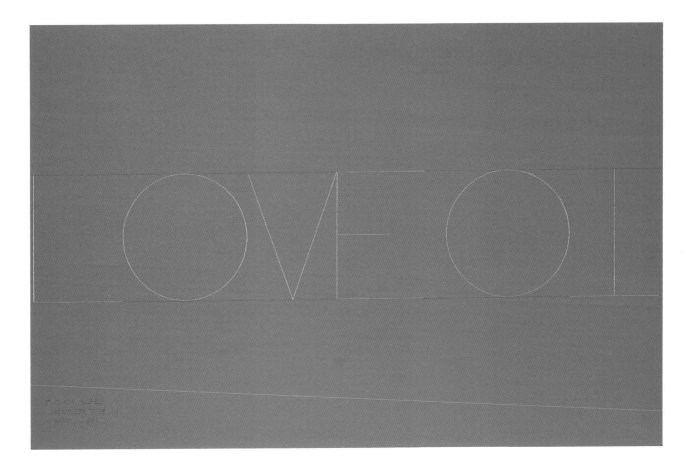

83

Robert Barry *LOVE TO (Study for Wallpiece)*, 1984 (cat. 13)

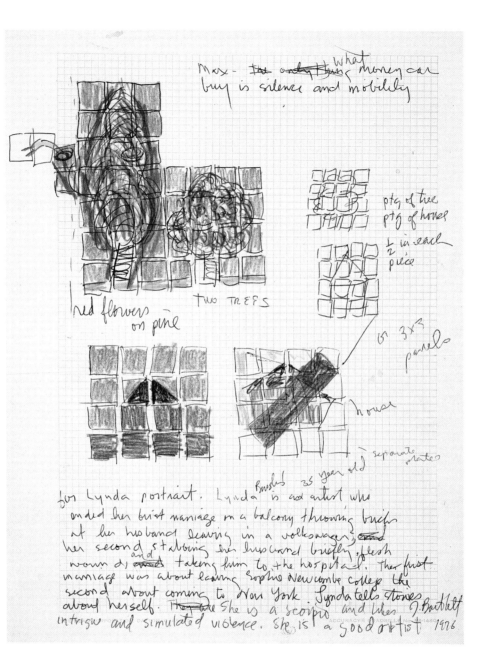

84

Jennifer Bartlett *Untitled (Two Trees,
Two Houses, Portrait of Lynda Benglis),*
1976 (cat. 14)

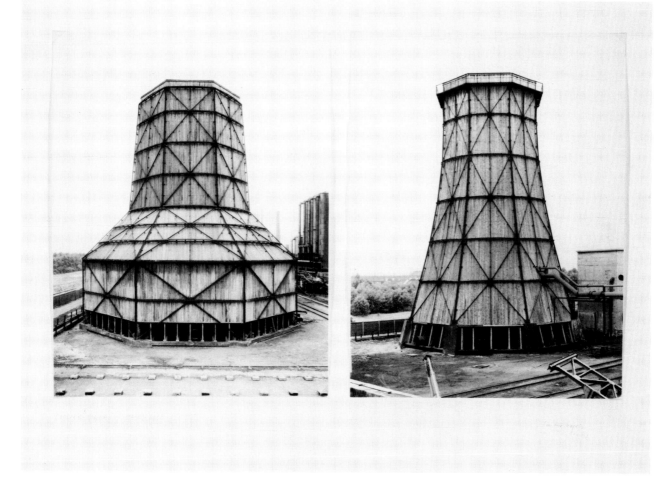

Bernd and Hilla Becher *Cooling Towers/Steel-Wood*, 1972 (cat. 15)

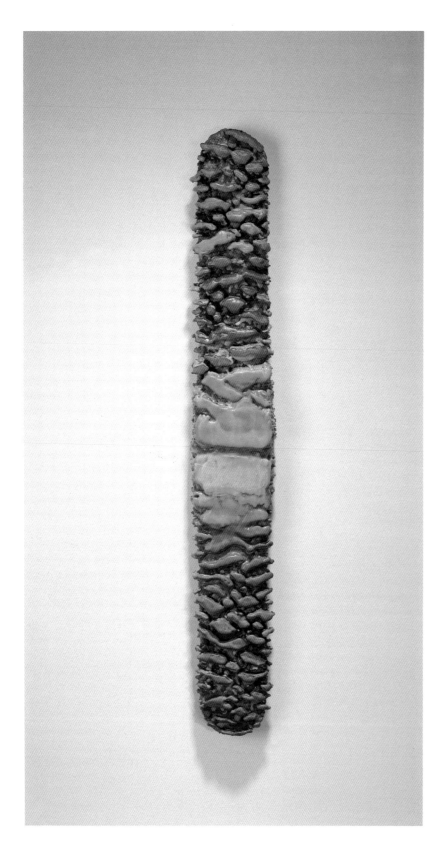

I wanted to make something that related to the body, that was humanistic, and not machine-like; that had holes in it that perhaps suggested orifices, but also might suggest the process of wax, on a horizontal base, dripping into these holes.[7]

—Lynda Benglis, 1982

86

Lynda Benglis *Untitled*, 1971 (cat. 18)

Drawing is the first visible form of my work, the first visible form of the thought . . . it is not merely a description of the thought. . . . you have also incorporated the senses—balance, sight, hearing, touch. . . . the thought becomes modified by other creative strata within the anthropological entity, the human being. . . . And then the last, most important thing is that some transfers from the invisible to the visible end with a sound, since the most important production of human beings is language. . . . This wide understanding, this wider understanding of drawing is very important for me.[8]

—**Joseph Beuys, 1984**

87

Joseph Beuys *Perception* (recto), 1970
(cat. 19)

88

James Bishop *Untitled*, 1973 (cat. 22)

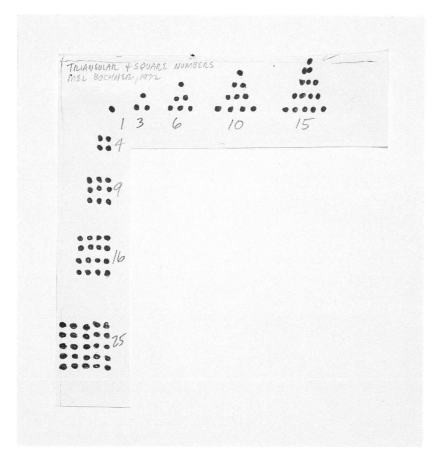

89

Mel Bochner *Triangular + Square Numbers*, 1972 (cat. 23)

Doing upside-down paintings was a way of throwing more irrationality into my image making.[10]

—Jonathan Borofsky, 1983

90

Jonathan Borofsky *Seascape*, 1977
(cat. 25)

Whether in a gallery, museum, street, public setting, or private residence, the work of art always emerges from the site and from the human beings who occupy that site. . . . The site inspires, constrains and liberates.[11]

—Daniel Buren, 1988

Daniel Buren *Untitled*, 1970 (cat. 26)

92

André Cadere *B12004030=35=9x10=*,
1976 (cat. 27)

What we need in our lives is a use of
art which alters our lives—is useful in
our lives.[12]

—John Cage

I have nothing to say and I am saying
it and that is poetry.[13]

—John Cage

John Cage *Music for Carillon #4, Page 1,*
1961 (cat. 28)

The fabric is a very important part of my work. Friedrich Engels said that fabric made man different from primitive man. . . . fabric is almost like an extension of our skin. . . .[14]

 —Christo, 1979

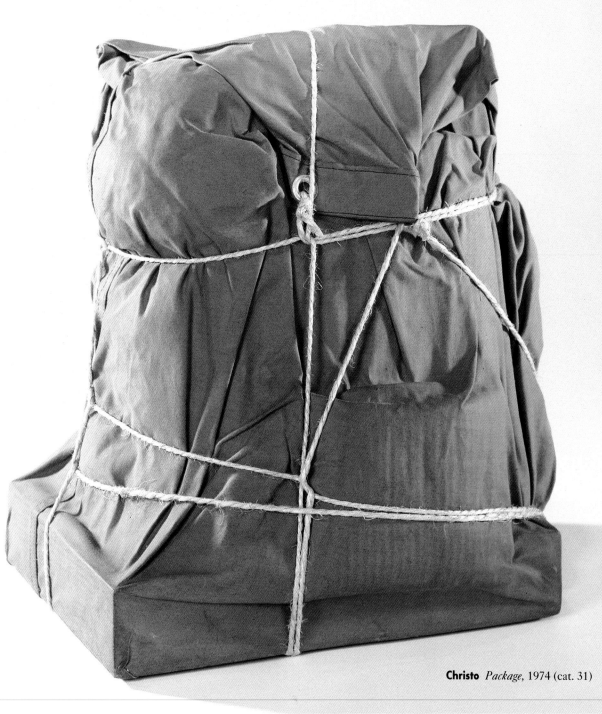

Christo *Package*, 1974 (cat. 31)

My main objective is to translate
photographic information into paint
information.[15]

—Chuck Close, 1969

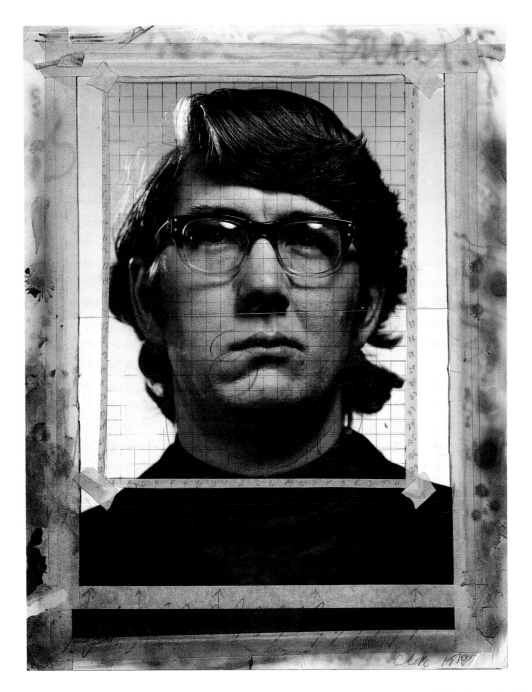

95

Chuck Close *Study for Keith*, 1970
(cat. 32)

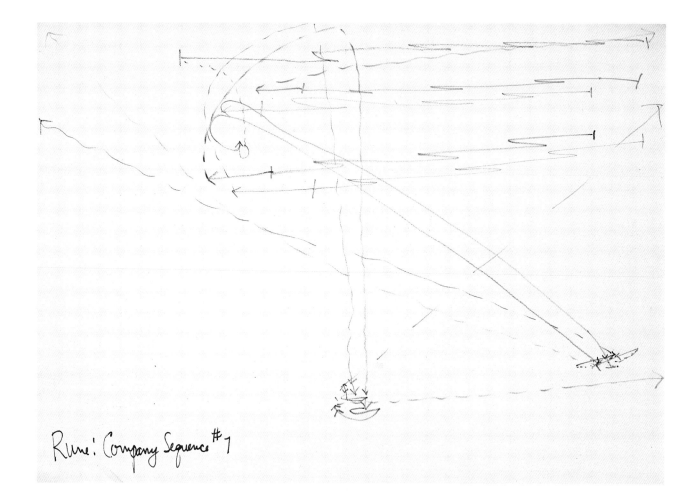

Rune: Company Sequence #7

Merce Cunningham *Rune: Company Sequence* #7, 1959 (cat. 33)

All art is construction. . . . This construction exists in time: the time it takes to make it and the time—the epoch or the period—when it is made. One can read the nature of society from its art, so all art is political. . . . Numbers . . . are an invention—perhaps the only real invention man has made.[16]

—Hanne Darboven, 1978

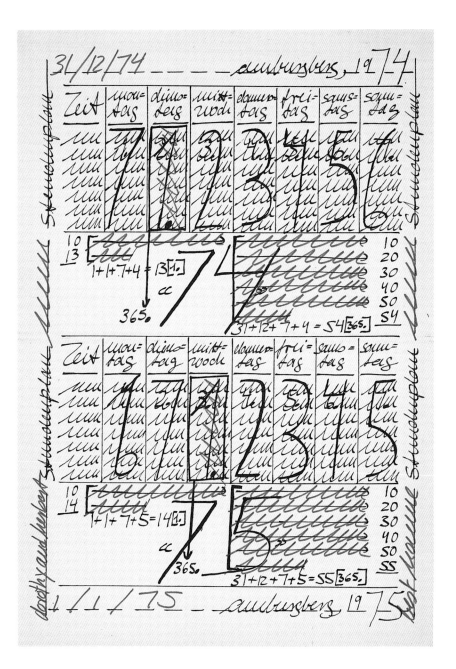

97

Hanne Darboven *Untitled*, 1974–1975
(cat. 34)

My works are not exactly made to be seen. They are more there so that you are given the fleeting feeling that something isn't right in the landscape.[17]

—Jan Dibbets, 1968

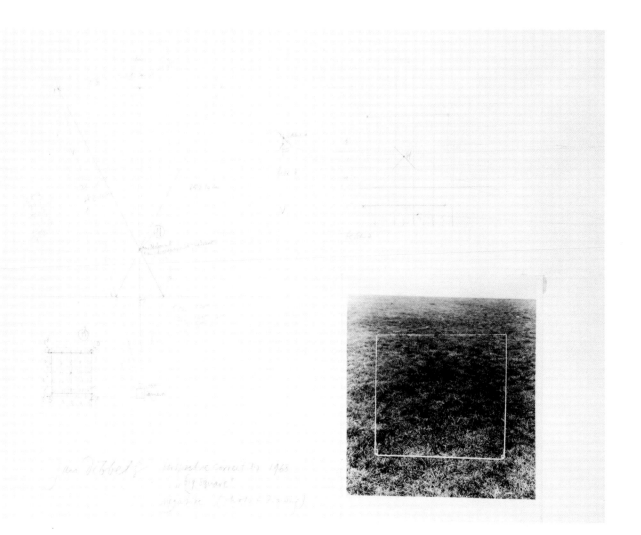

Jan Dibbets *Perspective Correction: Big Square*, 1968 (cat. 35)

My Webster's Collegiate Dictionary

does not connect "sensibility" to "art."[18]

—Dan Flavin, 1966

Dan Flavin *Variation on a Proposition
from Diagram 10 of January 22, 1964.
All Positions Possible Anywhere,* 1965
(cat. 37)

100

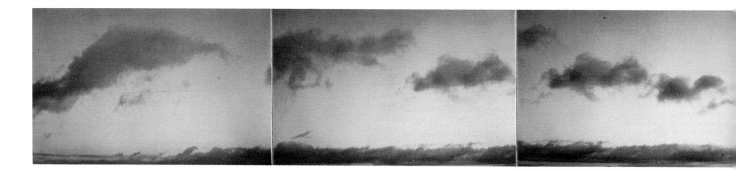

Architecture is architecture. Sculpture is sculpture. Models are models.[19]

—Dan Graham, 1967

Dan Graham *Sunrise and Sunset*, 1969 (cat. 38)

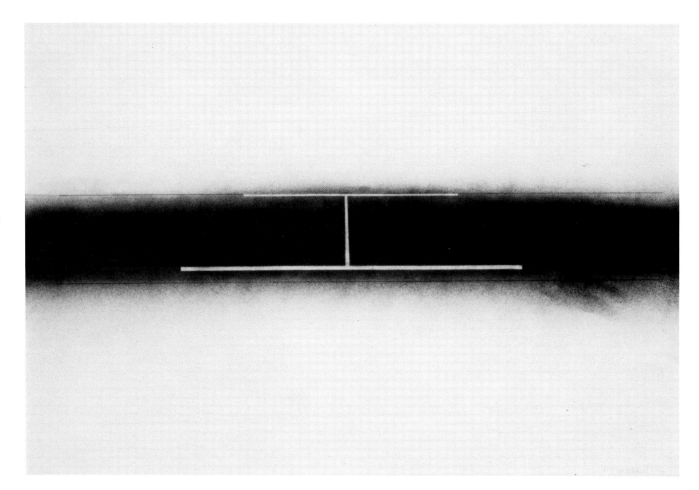

102

Robert Grosvenor *Untitled*, 1970 (cat. 41)

In my inner soul art and life are insep-
arable. It becomes more absurd and less
absurd to isolate a basically intuitive
idea and then work up some calculated
system and follow it through—that sup-
posedly being the more intellectual
approach—than giving precedence to
soul or presence or whatever you want
to call it. . . .[20]

—Eva Hesse, 1970

103

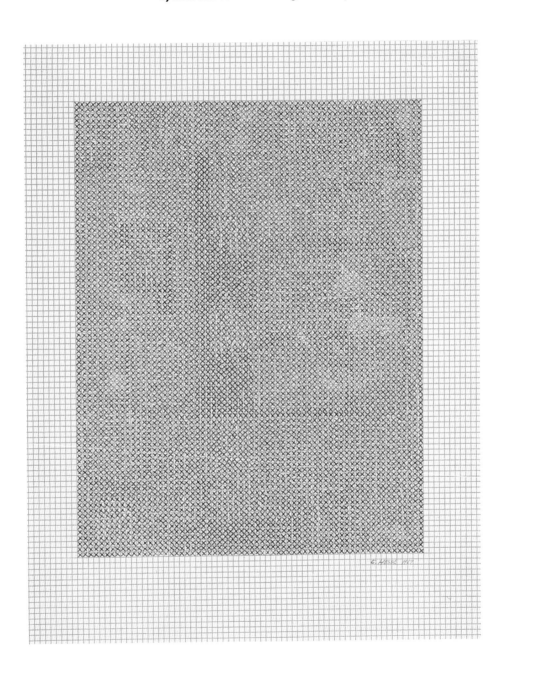

Eva Hesse *Untitled*, 1967 (cat. 42)

The world is full of objects, more or less interesting; I do not wish to add any more.

I prefer, simply to state the existence of things in terms of time and/or place. . . . This documentation takes the form of photographs, maps, drawings and descriptive language.[21]

—Douglas Huebler, 1969

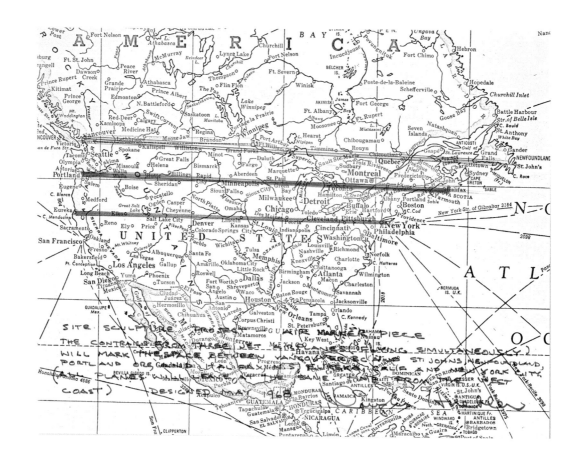

104

Douglas Huebler *Site Sculpture Project— Air Marker Piece, The Contrails from Three Jet Airplanes (Flying Simultaneously) Will Mark the Space between Vancouver, B.C. and St. Johns, Newfoundland, Portland Ore., and Halifax, N.S., Eureka, Calif. and New York City. (All Planes Will Leave at the Same Time from the West Coast),* 1968 (cat. 43)

One of the important things in any art is its degree of generality and specificity and another is how each of these occurs. The extent and the occurrence have to be credible. I'd like my work to be somewhat more specific than art has been and also specific and general in a different way.[22]

—Donald Judd, 1965

105

Donald Judd *Untitled*, 1968 (cat. 45)

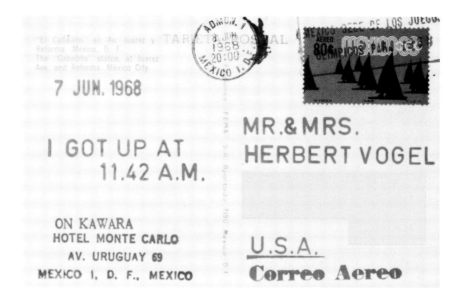

7 JUN. 1968

I GOT UP AT
11.42 A.M.

ON KAWARA
HOTEL MONTE CARLO
AV. URUGUAY 69
MEXICO I. D. F., MEXICO

MR.&MRS.
HERBERT VOGEL

U.S.A.
Correo Aereo

On Kawara *I GOT UP AT* …, 1968/1969
(cat. 46, detail); 7 June 1968 (recto with
address masked, and verso)

My art objects are total, complete, and disinterested. They are m[a]de of non-organic, non-polar, completely synthetic, completely unnatural, yet of conceptual rather than found materials.[23]

—Joseph Kosuth, 1969

All I make are models. The actual works of art are ideas. . . . Insofar as they are, as models, objects concerned with art—they are art objects.[24]

—Joseph Kosuth, 1967

107

Joseph Kosuth *Art as Idea: Nothing,* 1968
(cat. 48)

In conceptual art the idea or concept is the most important aspect of the work. . . . When an artist uses a conceptual form of art, it means that all of the planning and decisions are made beforehand and the execution is a perfunctory affair. The idea becomes a machine that makes the art. This kind of art is not theoretical or illustrative of theories; it is intuitive.[25]

—Sol LeWitt, 1967

Sol LeWitt *Wall Drawing No. 681 C. A wall divided vertically into four equal squares separated and bordered by black bands. Within each square, bands in one of four directions, each with color ink washes superimposed*, first installation 1993 (cat. 52)

I was for art made on common land, by simple means, on a human scale.[26]

—Richard Long, 1983

110

Richard Long *England* [formerly titled *Plucked Daisies, Durham Downs, Bristol*], 1968 (cat. 53)

A principal involvement in my work during the last ten years has been my concern with structure, the relation of the interior structure of the piece to the exterior shape. Edge line to inner line.[27]

—Robert Mangold, 1975

111

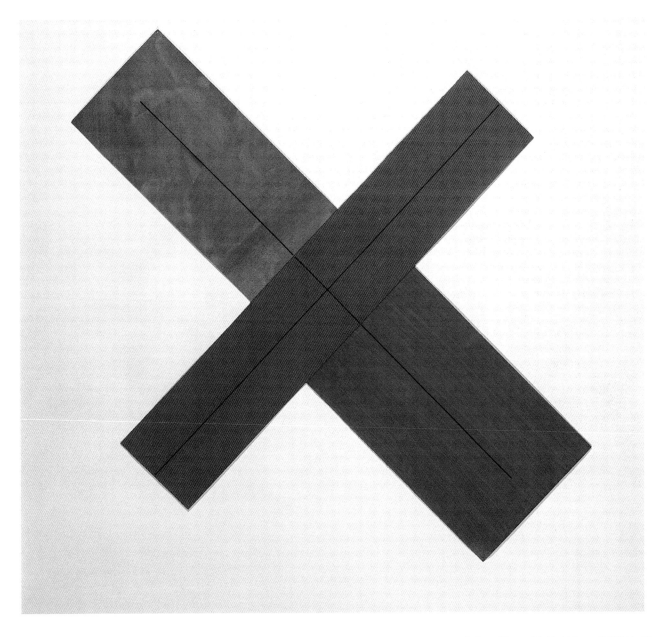

Robert Mangold *Red/Green X Within X,* 1981 (cat. 56)

The landscape paintings appear to be about landscape. In my mind these works are as much about the painting of the perimeter of the landscape. The subject is the perimeter. . . . There is so much information on the edges, that the information is disguised as illusion.[28]

—Sylvia Plimack Mangold, 1978

112

Sylvia Plimack Mangold *Untitled*, 1977
(cat. 57)

Painting creates a space on a wall.
That space is the expression of the
vision of the painter. The painter strives
to make his expression explicit because
he wants to affect man. By doing so he
works to keep man's spirit alive.[29]

—Brice Marden, 1975

113

Brice Marden *Untitled*, 1970 (cat. 60)

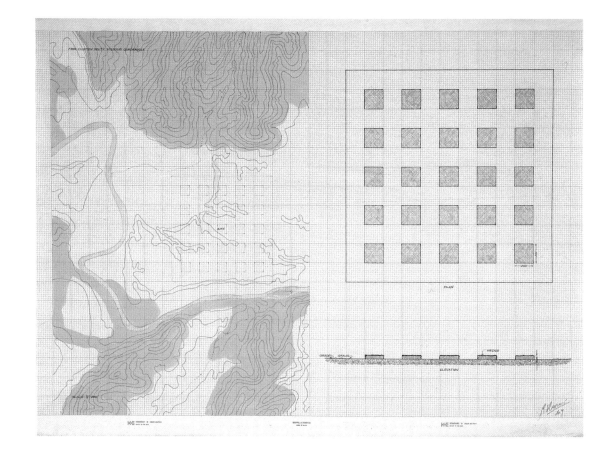

Robert Morris *Drawing for Earth Project,*
1969 (cat. 61)

It's the way the piece feels that counts—the way it changes that chunk of space you're both in, thickens it and makes it vibrate—like nouns slipping into verbs.[30]

—Richard Nonas, 1973

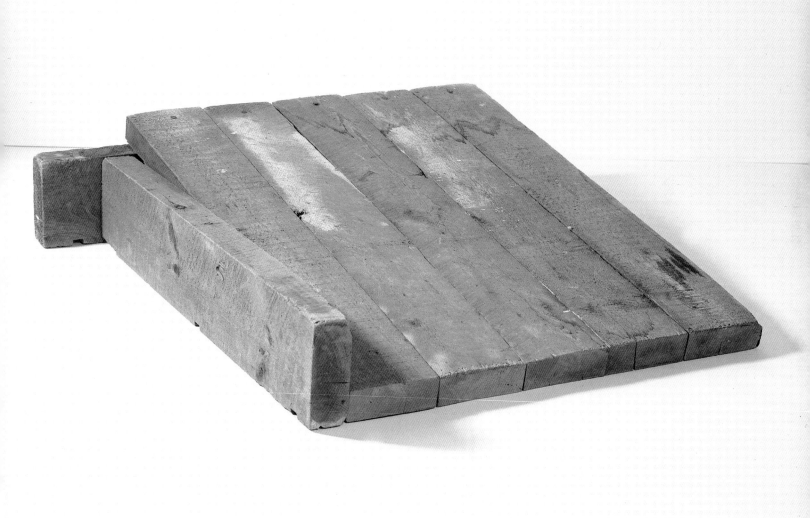

Richard Nonas *Good Time Shorty*, 1973
(cat. 63)

So the site-markers began the kind of extra studio activity. . . . it no longer depended upon the craft and it added . . . the notion of travel. . . . coupled with a sense of place. Place kind of took the place of object. And the apparatus that we used to relate to, methodology or forming, the craft, was now exchanged for conceptual energy.[31]

—Dennis Oppenheim, 1977

116

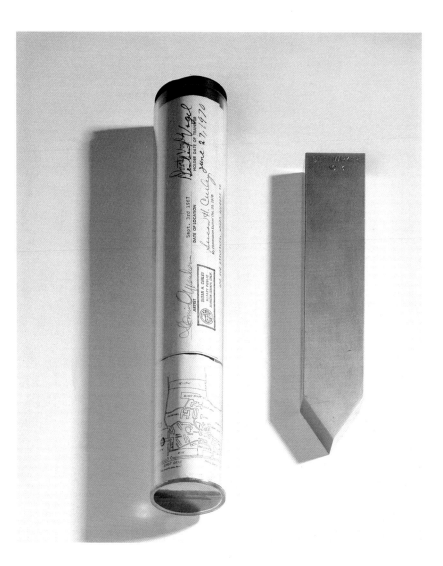

Dennis Oppenheim *Site Marker No. 3,* 1967 (cat. 65)

117

Nam June Paik *Dream TV,* 1973 (cat. 69)

You strike a match

There is a spark

There is energy, light

So it is with drawing[32]

—Edda Renouf, 1989

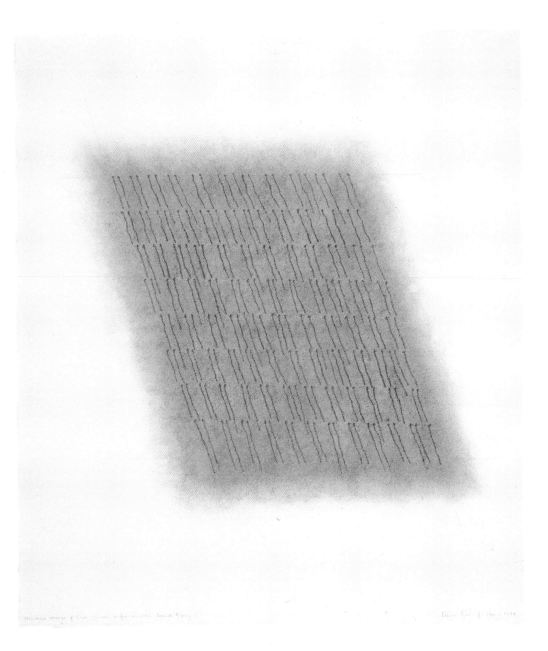

118

Edda Renouf *Structure Change of Lines incised before chalk—Sounds Rising I*, 1978 (cat. 71)

There is an abstract, conceptual, philosophical and visual line that you can draw in a drawing and also make in nature. I come from a generation of abstraction; as students, "abstract" was a very deep concept for us. To me reality is abstract, and then whatever lies around it are spaces which nobody has crossed, visually, perhaps only scientists. . . . We must have the courage simply to cross the frontiers. Art must not finish up in a gallery or a flat.[33]

—Klaus Rinke, 1976

119

Klaus Rinke *3 Meter vom Zei Town von 0–6m*, 1975 (cat. 73)

*Making art allows me to use a part of
myself which seems to have a life and
a learning which is separate from
everyday being. . . .*[34]
—**Dorothea Rockburne, 1989**

120

Dorothea Rockburne *Untitled*, 1970
(cat. 74)

I always pour sour milk over pictures that aren't beautiful or that don't work out. Sour milk is like landscape, ever changing. Works of art should be like that—they should change like man himself, grow old and die.[35]

—Dieter Roth, 1978

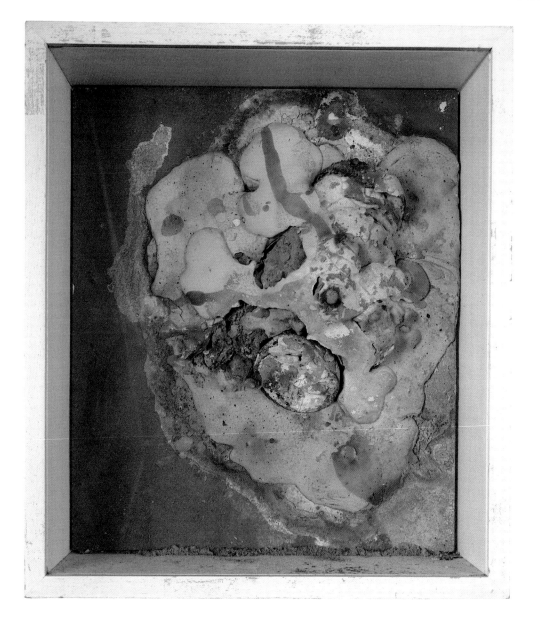

Dieter Roth *Insel*, 1968 (cat. 75)

New mediums encourage me . . . but what I'm interested in is illustrating ideas.[36]

—Edward Ruscha, 1970

Words have temperatures to me. When they reach a certain point and become hot words, then they appeal to me.[37]

—Edward Ruscha, 1972

Edward Ruscha *Colorfast?*, 1975 (cat. 76)

I use the white because it's neutral—it's a paint that allows other things to come into focus with the work. The surface, the subtle colors of the surface, the texture, the painting as a whole.[38]
—Robert Ryman, 1979

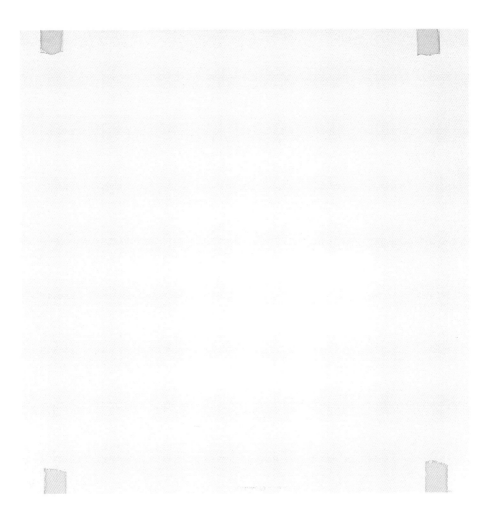

123

Robert Ryman *Untitled*, 1969 (cat. 77)

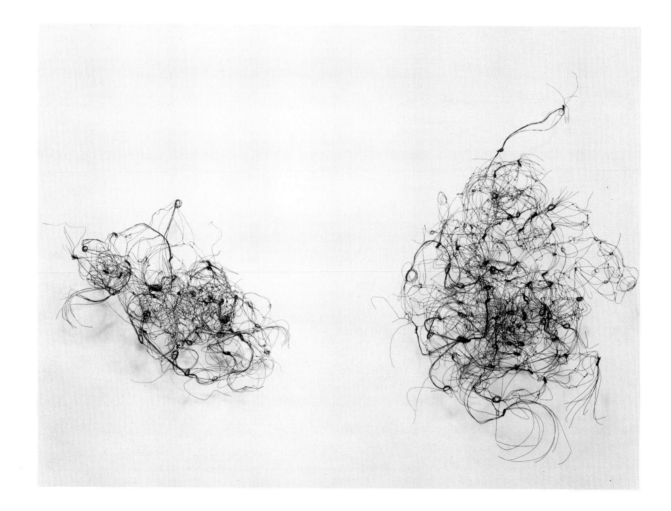

Alan Saret *Untitled*, 1975 (cat. 79)

Nothing looked richer than a house. I made the first house and put it on the floor and I looked at it and said, "Could that be sculpture?". . . I sensed that the house was a known situation—it was a metaphor for my past or for experience digested.[39]

—Joel Shapiro, **1982**

125

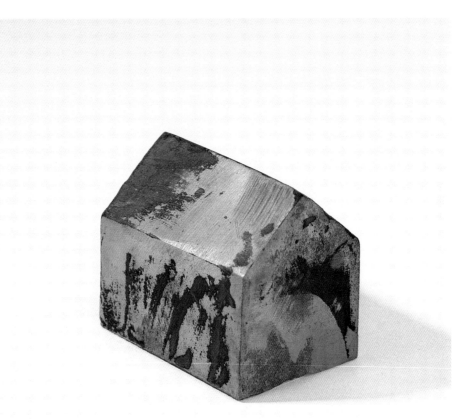

Joel Shapiro *Untitled*, 1975 (cat. 80)

I am for an art that takes into account the direct effect of the elements as they exist from day to day apart from representation.[40]

—**Robert Smithson, 1972**

126

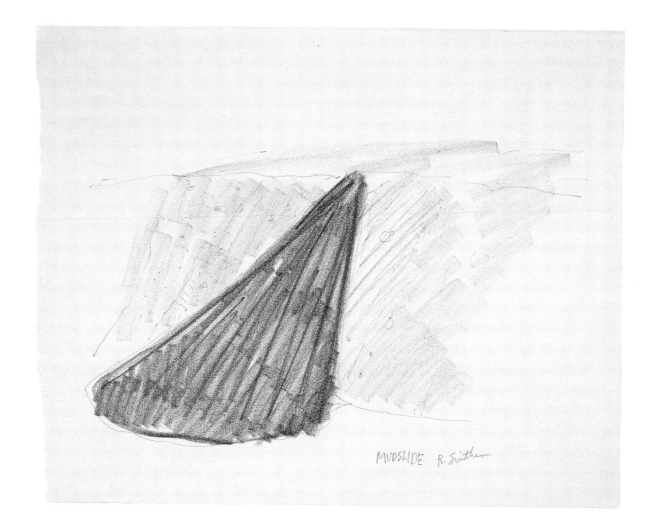

Robert Smithson *Mudslide*, 1969 (cat. 83)

127

Richard Tuttle *Monkey's Recovery for a Darkened Room (Bluebird)*, 1983 (cat. 86)

[What did you see as your main artistic concerns?] . . . just to maintain a dialectic with the culture.[41]

—Lawrence Weiner, 1971

128

Lawrence Weiner *Study for* "BROKEN OFF," 1993 (cat. 87)

Vito Acconci American, b. 1940

Cat. 1 *Step Piece*, 1970
five silver gelatin photographic prints,
type on four sheets of bond paper,
mounted together on paperboard with
felt-tip pen annotations
30 x 40 (76.2 x 101.6)
National Gallery of Art, Washington, The Dorothy
and Herbert Vogel Collection, Gift of Dorothy and
Herbert Vogel, Trustees 1994.17.1

Carl Andre American, b. 1935

Cat. 2 *Limbs*, 1965
printed papers mounted on paperboard
6¾ x 7½ (17.1 x 19.1)
The Dorothy and Herbert Vogel Collection

Cat. 3 *Little, Long, Ivory Equivalent*, 1977
ivory (six units)
each: ¾ x 2½ x 1⁄16 (1.9 x 6.4 x .2)
overall: ¾ x 15 x 1⁄16 (1.9 x 38.1 x .2)
National Gallery of Art, Washington, The Dorothy
and Herbert Vogel Collection, Ailsa Mellon Bruce
Fund, Patrons' Permanent Fund, and Gift of
Dorothy and Herbert Vogel 1991.241.5

Cat. 4 *Nine Steel Rectangles*, 1977
hot rolled steel (nine units)
each: 8¼ x 7¼ x ¼ (21 x 18.4 x .6)
overall: 24¾ x 21¾ x ¼ (62.9 x 55.3 x .6)
National Gallery of Art, Washington, The Dorothy
and Herbert Vogel Collection, Ailsa Mellon Bruce
Fund, Patrons' Permanent Fund, and Gift of
Dorothy and Herbert Vogel 1991.241.6

Cat. 5 *Star Fire*, 1978
copper (three units) and tin
(one unit) wire
each: 4⅜ x ⅛ x ⅛ (11.8 x .3 x .3)
overall: 9¼ x 9¼ x ⅛ (23.5 x 23.5 x .3)
The Dorothy and Herbert Vogel Collection,
Promised Gift of Dorothy and Herbert Vogel

Cat. 6 *Nine Pierced Steel Squares*, 1978
steel (nine units)
each: 2¼ x 2¼ x 3⁄16 (5.7 x 5.7 x .5)
overall: 6¾ x 6¾ x 3⁄16 (17.2 x 17.2 x .5)
National Gallery of Art, Washington, The Dorothy
and Herbert Vogel Collection, Ailsa Mellon Bruce
Fund, Patrons' Permanent Fund, and Gift of
Dorothy and Herbert Vogel 1991.241.8

Richard Artschwager American, b. 1923

Cat. 7 *Untitled (Mantlepiece)*, 1972
charcoal and acrylic polymer emulsion
on composition board with metal frame
overall: 17 11⁄16 x 24⅞ (45 x 63.1)
The Dorothy and Herbert Vogel Collection

Cat. 8 *Hair Sculpture—Shallow Recess
Box*, 1969
rubberized horsehair
30¾ x 11 x 7¾ (78.1 x 27.9 x 19.7)
National Gallery of Art, Washington, The Dorothy
and Herbert Vogel Collection, Ailsa Mellon Bruce
Fund, Patrons' Permanent Fund, and Gift of
Dorothy and Herbert Vogel 1991.241.12

Cat. 9 *Hair Sculpture—Shallow Recess
Box*, 1969
rubberized horsehair
12 x 9½ x 11½ (30.5 x 24.1 x 29.2)
National Gallery of Art, Washington, The Dorothy
and Herbert Vogel Collection, Ailsa Mellon Bruce
Fund, Patrons' Permanent Fund, and Gift of
Dorothy and Herbert Vogel 1991.241.13

Jo Baer American, b. 1929

Cat. 10 *Untitled*, 1968
oil on canvas (diptych)
each: 34 x 48 (86.4 x 121.9)
overall: 34 x 99 (86.4 x 251.8)
The Dorothy and Herbert Vogel Collection,
Promised Gift of Dorothy and Herbert Vogel

129

John Baldessari American, b. 1931

Cat. 11 *Prototype for Stereogram Series: Lady in Street*, 1975
silver gelatin photographic print reworked with colored inks, gouache on black paper, mounted together on black paperboard annotated with colored pencil and graphite
sheet: 14 x 13⅛ (35.6 x 33.3)
mount: 15 x 13⅞ (38.1 x 35.2)
The Dorothy and Herbert Vogel Collection

Robert Barry American, b. 1936

Cat. 12 *Closed Gallery*, 1969
four sheets of printed paper mounted on paperboard
13¾ x 33¼ (34.9 x 84.5)
The Dorothy and Herbert Vogel Collection, Promised Gift of Dorothy and Herbert Vogel

Cat. 13 *LOVE TO (Study for Wallpiece)*, 1984
gouache, silver pencil, and graphite on paper
11¾ x 17¹⁵⁄₁₆ (29.9 x 45.6)
The Dorothy and Herbert Vogel Collection, Promised Gift of Dorothy and Herbert Vogel

Cat. 13A *LOVE TO*, 1984
paint and crayon (wall installation)*
14 x 89 ft (4.3 x 27.1 m)
The Dorothy and Herbert Vogel Collection, Promised Gift of Dorothy and Herbert Vogel

*to be installed for the first time in this exhibition

Jennifer Bartlett American, b. 1941

Cat. 14 *Untitled (Two Trees, Two Houses, Portrait of Lynda Benglis)*, 1976
colored pencil and ball point pen on graph paper
11 x 8½ (27.9 x 21.6)
The Dorothy and Herbert Vogel Collection

Bernd and Hilla Becher German, b. 1931 and 1934

Cat. 15 *Cooling Towers/Steel-Wood*, 1972
two silver gelatin photographic prints

mounted on paperboard
left sheet: 9½ x 9½ (24.1 x 24.1)
right sheet: 9½ x 8⅛ (24.1 x 20.6)
mount: 10⅝ x 21¼ (27 x 54)
National Gallery of Art, Washington, The Dorothy and Herbert Vogel Collection, Gift of Dorothy and Herbert Vogel, Trustees 1994.17.2

Cat. 16 *Winding-Tower*, 1972
two silver gelatin photographic prints mounted on paperboard
left sheet: 9½ x 9½ (24.1 x 24.1)
right sheet: 9½ x 8⅛ (24.1 x 20.6)
mount: 10⅝ x 21½ (27 x 54)
National Gallery of Art, Washington, The Dorothy and Herbert Vogel Collection, Gift of Dorothy and Herbert Vogel, Trustees 1994.17.3

Lynda Benglis American, b. 1941

Cat. 17 *Untitled*, 1967
beeswax, pigment, and spray enamel on paper
30½ x 22½ (77.5 x 57.2)
The Dorothy and Herbert Vogel Collection

Cat. 18 *Untitled*, 1971
beeswax, dammar resin, pigment, and gesso on wood
36 x 5⅜ x 3¼ (91.4 x 13.7 x 8.3)
National Gallery of Art, Washington, The Dorothy and Herbert Vogel Collection, Ailsa Mellon Bruce Fund, Patrons' Permanent Fund, and Gift of Dorothy and Herbert Vogel 1991.241.31

Joseph Beuys German, 1921–1986

Cat. 19 *Perception*, 1970
recto: graphite and rubber stamps on paper from spiral bound drawing pad
verso: graphite
9⁷⁄₁₆ x 12¾ (24 x 32.4)
The Dorothy and Herbert Vogel Collection

Cat. 20 *Untitled*, 1970
recto: graphite and rubber stamp on paper from spiral bound drawing pad
verso: graphite
12¾ x 9⁷⁄₁₆ (32.4 x 24)
National Gallery of Art, Washington, The Dorothy and Herbert Vogel Collection, Gift of Dorothy and Herbert Vogel, Trustees 1994.17.4. a–b

James Bishop American, b. 1927

Cat. 21 *Untitled*, 1970
oil on paper
22 x 22 (55.9 x 55.9)
The Dorothy and Herbert Vogel Collection,
Promised Gift of Dorothy and Herbert Vogel

Cat. 22 *Untitled*, 1973
oil on paper
22 x 22 (55.9 x 55.9)
The Dorothy and Herbert Vogel Collection,
Promised Gift of Dorothy and Herbert Vogel

Mel Bochner American, b. 1940

Cat. 23 *Triangular + Square Numbers*,
1972
felt-tip pen and graphite on paper
sheet cut as a right angle:
9⅜–2 x 7⅜–1¾ (24.5 –5.1 x 18.7 –4.5)
National Gallery of Art, Washington, The Dorothy
and Herbert Vogel Collection, Gift of Dorothy and
Herbert Vogel, Trustees 1994.17.5

Jonathan Borofsky American, b. 1942

Cat. 24 *Upside Down Flowers*, 1976
charcoal on paper
23⅜ x 18 (60 x 45.7)
National Gallery of Art, Washington, The Dorothy
and Herbert Vogel Collection, Gift of Dorothy and
Herbert Vogel, Trustees 1994.17.6

Cat. 25 *Seascape*, 1977
charcoal on paper
14¼ x 22 (36.2 x 55.9)
The Dorothy and Herbert Vogel Collection

Daniel Buren French, b. 1938

Cat. 26 *Untitled*, 1970
acrylic on woven cloth
25½ x 55½ (64.8 x 141)
The Dorothy and Herbert Vogel Collection,
Promised Gift of Dorothy and Herbert Vogel

André Cadere Romanian, 1934 –1978

Cat. 27 *B12004030=35=9x10=*, 1976
painted wood
70⅛ x 1⅜ x 1⅜ (178.1 x 3.5 x 3.5)
The Dorothy and Herbert Vogel Collection,
Promised Gift of Dorothy and Herbert Vogel

John Cage American, 1912 –1992

Cat. 28 *Music for Carillon #4, Page 1*,
1961
ink on graph paper mounted on paper-
board
sheet: 11 x 16½ (27.9 x 41.9)
mount: 12 x 17 (30.5 x 43.2)
National Gallery of Art, Washington, The Dorothy
and Herbert Vogel Collection, Ailsa Mellon Bruce
Fund, Patrons' Permanent Fund, and Gift of
Dorothy and Herbert Vogel 1991.241.41

Cat. 29 *Solo for Flute (Concert for Piano
and Orchestra): Sketch*, 1957 –1958
graphite on paper
sheet: 11 x 8½ (28 x 21.6)
mount: 14 x 11 (35.6 x 27.9)
National Gallery of Art, Washington, The Dorothy
and Herbert Vogel Collection, Ailsa Mellon Bruce
Fund, Patrons' Permanent Fund, and Gift of
Dorothy and Herbert Vogel 1991.241.43

Christo American, b. 1935

Cat. 30 *Valley Curtain, Project for Rifle,
Colorado*, collage 1971
colored crayon and graphite on photo-
stat, fabric, and two blueprints,
mounted together on paperboard
27¹³⁄₁₆ x 22 (70.7 x 55.9)
National Gallery of Art, Washington, The Dorothy
and Herbert Vogel Collection, Ailsa Mellon Bruce
Fund, Patrons' Permanent Fund, and Gift of
Dorothy and Herbert Vogel 1992.7.1

Cat. 31 *Package 1974*, 1974
tarpaulin, wood, and rope
24 x 19½ x 15 (60.9 x 49.5 x 38.1)
National Gallery of Art, Washington, The Dorothy
and Herbert Vogel Collection, Ailsa Mellon Bruce
Fund, Patrons' Permanent Fund, and Gift of
Dorothy and Herbert Vogel 1992.7.3

Chuck Close American, b. 1940

Cat. 32 *Study for Keith*, 1970
transparent plastic sheet with ink and
black grease pencil annotations, adhered
by masking tape with graphite annota-
tions to two silver gelatin photographic
prints, adhered by masking tape to paper-
board with air brush paint marks overall
22 x 17 (55.9 x 43.2)
The Dorothy and Herbert Vogel Collection

Merce Cunningham American, b. 1919

Cat. 33 *Rune: Company Sequence #7*, 1959
colored inks on paper mounted to
paperboard
sheet: 10 x 14 (25.4 x 35.6)
mount: 11 x 14 (27.9 x 35.6)
National Gallery of Art, Washington, The Dorothy
and Herbert Vogel Collection, Gift of Dorothy and
Herbert Vogel, Trustees 1994.17.7

Hanne Darboven German, b. 1941

Cat. 34 *Untitled*, 1974–1975
felt-tip pen on photocopy on paper
16½ x 11¹¹⁄₁₆ (41.9 x 29.7)
The Dorothy and Herbert Vogel Collection,
Promised Gift of Dorothy and Herbert Vogel

Jan Dibbets Dutch, b. 1941

Cat. 35 *Perspective Correction: Big Square*,
1968
silver gelatin photographic print and
graphite on paper
20⅞ x 26⅝ (53 x 67.6)
The Dorothy and Herbert Vogel Collection

Cat. 36 *Untitled*, 1969
ink and graphite on graph and lined
papers
12⅞ x 16⁷⁄₁₆ (32.7 x 41.8)
The Dorothy and Herbert Vogel Collection,
Promised Gift of Dorothy and Herbert Vogel

Dan Flavin American, b. 1933

Cat. 37 *Variation on a Proposition from
Diagram 10 of January 22, 1964. All
Positions Possible Anywhere*, 1965
colored pencil and graphite on paper
12 x 25½ (30.5 x 64.8)
The Dorothy and Herbert Vogel Collection

Dan Graham American, b. 1942

Cat. 38 *Sunrise and Sunset*, 1969
six chromogenic photographic prints
mounted on paperboard
2¾ x 26½ (7 x 67.3)
The Dorothy and Herbert Vogel Collection,
Promised Gift of Dorothy and Herbert Vogel

Cat. 39 *Untitled*, 1993
ink, graphite, and colored pencil
on paper
14 ¹⁄₁₆ x 17 (35.8 x 42.3)
The Dorothy and Herbert Vogel Collection,
Promised Gift of Dorothy and Herbert Vogel

Robert Grosvenor American, b. 1937

Cat. 40 *Untitled*, 1967
graphite and tape on tracing paper
14 x 16⅞ (35.6 x 42.9)
The Dorothy and Herbert Vogel Collection,
Promised Gift of Dorothy and Herbert Vogel

Cat. 41 *Untitled*, 1970
graphite and spray paint on two-ply
Bainbridge Bristol board
14¹⁵⁄₁₆ x 22⅛ (37.9 x 56.2)
The Dorothy and Herbert Vogel Collection,
Promised Gift of Dorothy and Herbert Vogel

Eva Hesse American, 1936–1970

Cat. 42 *Untitled*, 1967
ink on graph paper
11 x 8½ (27.9 x 21.6)
The Dorothy and Herbert Vogel Collection

Douglas Huebler American, b. 1924

Cat. 43 *Site Sculpture Project —Air
Marker Piece, The Contrails from Three Jet
Airplanes (Flying Simultaneously) Will
Mark the Space between Vancouver, B.C.
and St. Johns, Newfoundland, Portland
Ore., and Halifax, N.S., Eureka, Calif. and
New York City. (All Planes Will Leave at the
Same Time from the West Coast)*, 1968
felt-tip pen and colored pencil on
photocopy on paper
8½ x 11 (21.6 x 27.9)
The Dorothy and Herbert Vogel Collection,
Promised Gift of Dorothy and Herbert Vogel

Donald Judd American, 1928–1994

Cat. 44 *Untitled*, 1965
galvanized iron and Plexiglas
6 x 27 x 24 (15.2 x 68.6 x 60.9)
National Gallery of Art, Washington, The Dorothy
and Herbert Vogel Collection, Ailsa Mellon Bruce
Fund, Patrons' Permanent Fund, and Gift of
Dorothy and Herbert Vogel 1991.241.49

Cat. 45 *Untitled*, 1968
oil on wood
26 x 16 x 2 (66 x 40.6 x 5.1)
National Gallery of Art, Washington, The Dorothy
and Herbert Vogel Collection, Ailsa Mellon Bruce
Fund, Patrons' Permanent Fund, and Gift of
Dorothy and Herbert Vogel 1991.241.51

On Kawara Japanese, b. 1933

Cat. 46 *I GOT UP AT . . .*, 1968/1969
fifteen postcards showing views of the
Americas with postage stamps (some
postmarked) and printed rubber stamps
each: 3⁷⁄₁₆ x 5³⁄₈ (8.7 x 13.7)
The Dorothy and Herbert Vogel Collection,
Promised Gift of Dorothy and Herbert Vogel

Joseph Kosuth American, b. 1945

Cat. 47 *Art as Idea: Normal*, 1967
silver gelatin photographic print
48½ x 48¼(123.2 x 122.6)
The Dorothy and Herbert Vogel Collection,
Promised Gift of Dorothy and Herbert Vogel

Cat. 48 *Art as Idea: Nothing*, 1968
silver gelatin photographic print
36 x 36 (91.4 x 91.4)
The Dorothy and Herbert Vogel Collection

Sol LeWitt American, b. 1928

Cat. 49 *Floor Structure Black*, 1965
painted wood
18½ x 18 x 82 (47 x 45.7 x 208.3)
National Gallery of Art, Washington, The Dorothy
and Herbert Vogel Collection, Ailsa Mellon Bruce
Fund, Patrons' Permanent Fund, and Gift of
Dorothy and Herbert Vogel 1991.241.53

Cat. 50 *Serial Project No. 1 B5*, 1969
baked enamel on aluminum
(three parts)
cube: 6¾ x 6¾ x 6¾ (17.2 x 17.2 x 17.2)
open form: 6¾ x 19¼ x 19¼
(17.2 x 48.9 x 48.9)
base: 1¼ x 32 x 32 (3.1 x 81.3 x 81.3)
overall: 8 x 32 x 32 (20.3 x 81.3 x 81.3)
National Gallery of Art, Washington, The Dorothy
and Herbert Vogel Collection, Ailsa Mellon Bruce
Fund, Patrons' Permanent Fund, and Gift of
Dorothy and Herbert Vogel 1991.241.56

Cat. 51 *Wall Drawing No. 26. A one-inch
(2.5 cm) grid covering a 36˝ (90 cm)
square. Within each one-inch (2.5 cm)
square, there is a line in one of the four
directions,* first installation 1969
black pencil (wall installation)
36 x 36 (91.4 x 91.4)
National Gallery of Art, Washington, The Dorothy
and Herbert Vogel Collection, Ailsa Mellon Bruce
Fund, Patrons' Permanent Fund, and Gift of
Dorothy and Herbert Vogel 1991.241.57

Cat. 52 *Wall Drawing No. 681 C. A wall
divided vertically into four equal squares
separated and bordered by black bands.
Within each square, bands in one of four
directions, each with color ink washes super-
imposed,* first installation 1993
color ink washes (wall installation)
10 x 37 ft (3 x 11.2 m)
National Gallery of Art, Washington, The Dorothy
and Herbert Vogel Collection, Gift of Dorothy
Vogel and Herbert Vogel, Trustees 1993.41.1

Richard Long British, b. 1945

Cat. 53 *England* [formerly titled *Plucked
Daisies, Durham Downs, Bristol*], 1968
silver gelatin photographic print
mounted on Fome-Cor
30 x 40 (76.2 x 101.6)
The Dorothy and Herbert Vogel Collection

Robert Mangold American, b. 1937

Cat. 54 *Light—Neutral Area*, 1966
oil and flat lacquer on hardboard
30 x 34½ (76.2 x 87.6)
National Gallery of Art, Washington, The Dorothy
and Herbert Vogel Collection, Ailsa Mellon Bruce
Fund, Patrons' Permanent Fund, and Gift of
Dorothy and Herbert Vogel 1991.241.85

Cat. 55 *½ X Series (Medium Scale)*, 1968
acrylic on incised hardboard
24 x 48 (60.9 x 121.9)
National Gallery of Art, Washington, The Dorothy
and Herbert Vogel Collection, Ailsa Mellon Bruce
Fund, Patrons' Permanent Fund, and Gift of
Dorothy and Herbert Vogel 1992.7.10

Cat. 56 *Red/Green X Within X*, 1981
acrylic and graphite on paper mounted
on paperboard
44⅛ x 43⅞ (112 x 111.5)
National Gallery of Art, Washington, The Dorothy
and Herbert Vogel Collection, Ailsa Mellon Bruce
Fund, Patrons' Permanent Fund, and Gift of
Dorothy and Herbert Vogel 1992.7.11

Sylvia Plimack Mangold American,
b. 1938

Cat. 57 *Untitled*, 1977
acrylic and graphite on Strathmore paper
30 x 40 (76.2 x 101.6)
National Gallery of Art, Washington, The Dorothy
and Herbert Vogel Collection, Ailsa Mellon Bruce
Fund, Patrons' Permanent Fund, and Gift of
Dorothy and Herbert Vogel 1991.241.125

Cat. 58 *Untitled*, 1979
oil on canvas
15 x 20 (38.1 x 50.8)
National Gallery of Art, Washington, The Dorothy
and Herbert Vogel Collection, Ailsa Mellon Bruce
Fund, Patrons' Permanent Fund, and Gift of
Dorothy and Herbert Vogel 1991.241.127

Brice Marden American, b. 1938

Cat. 59 *Untitled*, 1964–1970
graphite and wax with incised lines
on paper
11 x 14¼ (27.9 x 36.2)
The Dorothy and Herbert Vogel Collection

Cat. 60 *Untitled*, 1970
graphite and wax with incised lines on
paper
10¾ x 14¾ (27.3 x 37.5)
The Dorothy and Herbert Vogel Collection

Robert Morris American, b. 1931

Cat. 61 *Drawing for Earth Project*, 1969
colored inks, watercolor, and colored
pencil on graph paper
22 x 30 (55.9 x 76.2)
National Gallery of Art, Washington, The Dorothy
and Herbert Vogel Collection, Gift of Dorothy and
Herbert Vogel, Trustees 1994.17.8

Cat. 62 *Untitled (drawing for project
constructed in Norman, OK 10/69)*, 1969
ink on paper
19⅛ x 25 (48.6 x 63.5)
The Dorothy and Herbert Vogel Collection

Richard Nonas American, b. 1936

Cat. 63 *Good Time Shorty*, 1973
wood
11 x 45 x 48 (27.9 x 114.3 x 121.9)
The Dorothy and Herbert Vogel Collection,
Promised Gift of Dorothy and Herbert Vogel

Cat. 64 *Two Part Drawing for Herb
& Dorothy*, 1980
gouache on two sheets of paper
mounted ½ inch apart
left sheet: 24¹¹⁄₁₆ x 32⅜ (62.9 x 82.2)
right sheet: 24¹¹⁄₁₆ x 4⅞ (62.9 x 12.4)
The Dorothy and Herbert Vogel Collection,
Promised Gift of Dorothy and Herbert Vogel

Dennis Oppenheim American, b. 1938

Cat. 65 *Site Marker No. 3*, 1967
anodized aluminum marker; two legal
documents and silver gelatin photo-
graphic print of site in plastic tube with
rubber stopper
marker: 9¾ x 2 x 1 (24.8 x 5.1 x 2.5)
tube: 13⁷⁄₁₆ x 2½ x 2½ (34.2 x 6.4 x 6.4)
The Dorothy and Herbert Vogel Collection,
Promised Gift of Dorothy and Herbert Vogel

Cat. 66 *Gallery Transplant (Stedelijk
Museum)*, 1969
silver gelatin photographic print, printed
map with graphite annotations, photo-
copy with felt-tip pen annotations,
mounted together on paperboard
overall: 29 x 23 (73.7 x 58.4)
The Dorothy and Herbert Vogel Collection

Cat. 67 *Stage 1 and 2. Reading Position for
2nd Degree Burn Long Island. N.Y.
Material… Solar Energy. Skin Exposure
Time. 5 Hours June 1970*, 1970
two chromogenic photographic prints,
plastic labeling tape, mounted together
on green board with graphite annotations
sheet: 16⅜ x 10 (41.6 x 25.4)
mount: 31⅞ x 26 (81 x 66)
The Dorothy and Herbert Vogel Collection

Nam June Paik American, b. 1932

Cat. 68 *Cinemascope/Dreamscope TV,*
1973
graphite on paper mounted on black
paper
20⅞ x 26¾ (53 x 67.9)
The Dorothy and Herbert Vogel Collection,
Promised Gift of Dorothy and Herbert Vogel

Cat. 69 *Dream TV,* 1973
graphite on paper mounted on black
paper with chalk and graphite annotations
25¼ x 19¾ (65.4 x 50.2)
The Dorothy and Herbert Vogel Collection,
Promised Gift of Dorothy and Herbert Vogel

Edda Renouf American, b. 1943

Cat. 70 *Percussion Drawing 19—lines*
incised after chalk and rubbed with one layer
of chalk, 1977
chalk and incised lines on paper
22 x 22 (55.9 x 55.9)
National Gallery of Art, Washington, The Dorothy
and Herbert Vogel Collection, Gift of Dorothy and
Herbert Vogel, Trustees 1994.17.9

Cat. 71 *Structure Change of Lines incised*
before chalk—Sounds Rising I, 1978
incised lines, pastel, and graphite
on paper
21 x 18½ (53.3 x 47)
National Gallery of Art, Washington, The Dorothy
and Herbert Vogel Collection, Gift of Dorothy and
Herbert Vogel, Trustees 1994.17.10

Cat. 72 *lines incised before gray chalk—*
white plus gray, points—verticals II, 1979
incised lines, chalk, and graphite on
paper
20⅞ x 18½ (53 x 47)
National Gallery of Art, Washington, The Dorothy
and Herbert Vogel Collection, Gift of Dorothy and
Herbert Vogel, Trustees 1994.17.11

Klaus Rinke German, b. 1939

Cat. 73 *3 Meter vom Zei Town von*
0–6m, 1975
graphite and incised lines on paper
29¾ x 22⅛ (75.6 x 56.2)
The Dorothy and Herbert Vogel Collection,
Promised Gift of Dorothy and Herbert Vogel

Dorothea Rockburne Canadian, b. 1934

Cat. 74 *Untitled,* 1970
oil on paper and board with nails
overall: 29¾ x 20 (75.6 x 50.8)
The Dorothy and Herbert Vogel Collection

Dieter Roth German, b. 1930

Cat. 75 *Insel,* 1968
plaster, yogurt, orange, and mildew
on wood
15¼ x 13¼ x 4¾ (38.7 x 33.7 x 12.1)
The Dorothy and Herbert Vogel Collection,
Promised Gift of Dorothy and Herbert Vogel

Edward Ruscha American, b. 1937

Cat. 76 *Colorfast?,* 1975
beet juice and graphite on paper
7¹³⁄₁₆ x 29¹⁄₁₆ (19.7 x 73.9)
The Dorothy and Herbert Vogel Collection

Robert Ryman American, b. 1930

Cat. 77 *Untitled,* 1969
acrylic on mylar
15 x 15 (38.1 x 38.1)
The Dorothy and Herbert Vogel Collection

Cat. 78 *Untitled,* 1969
acrylic on corrugated cardboard
36 x 36 (91.4 x 91.4)
The Dorothy and Herbert Vogel Collection

Alan Saret American, b. 1944

Cat. 79 *Untitled,* 1975
galvanized steel wire (two units)
left: approx. 25 x 32 x 22
(63.5 x 81.3 x 55.9)
right: approx. 45 x 43 x 22
(114.3 x 109.2 x 55.9)
The Dorothy and Herbert Vogel Collection,
Promised Gift of Dorothy and Herbert Vogel

Joel Shapiro American, b. 1941

Cat. 80 *Untitled*, 1975
cast iron
2⅞ x 3¼ x 2⅜ (7.3 x 8.2 x 6)
National Gallery of Art, Washington, The Dorothy
and Herbert Vogel Collection, Ailsa Mellon Bruce
Fund, Patrons' Permanent Fund, and Gift of
Dorothy and Herbert Vogel 1991.241.133

Cat. 81 *Untitled*, 1975
cast iron
2¾ x 6¼ x 5 (7 x 15.9 x 12.7)
National Gallery of Art, Washington, The Dorothy
and Herbert Vogel Collection, Ailsa Mellon Bruce
Fund, Patrons' Permanent Fund, and Gift of
Dorothy and Herbert Vogel 1991.241.132

Robert Smithson American, 1938–1973

Cat. 82 *Study for "Negative Halves,"* 1967
paper mounted on mirror
13¾ x 9 (34.9 x 22.9)
The Dorothy and Herbert Vogel Collection,
Promised Gift of Dorothy and Herbert Vogel

Cat. 83 *Mudslide*, 1969
crayon and felt-tip pen on paper
19 x 23½ (48.3 x 59.7)
The Dorothy and Herbert Vogel Collection

Richard Tuttle American, b. 1941

Cat. 84 *Turn*, 1965
acrylic on wood board
25¼ x 30¾ x 1⅛ (64.1 x 78.1 x 2.9)
National Gallery of Art, Washington, The Dorothy
and Herbert Vogel Collection, Gift of Dorothy and
Herbert Vogel, Trustees 1994.17.12

Cat. 85 *White Cotton Octagonal*, 1971
cotton cloth
41¼ x 35 (104.8 x 88.9)
The Dorothy and Herbert Vogel Collection,
Promised Gift of Dorothy and Herbert Vogel

Cat. 86 *Monkey's Recovery for a Darkened
Room (Bluebird)*, 1983
wood, wire, acrylic, matboard, string, and
cloth
40 x 20½ x 12½ (101.6 x 52.1 x 31.8)
The Dorothy and Herbert Vogel Collection,
Promised Gift of Dorothy and Herbert Vogel

Lawrence Weiner American, b. 1942

Cat. 87 *Study for "BROKEN OFF,"* 1993
aluminum paint, ink, and graphite
on paper
18¹⁵⁄₁₆ x 24 (48.1 x 61)
The Dorothy and Herbert Vogel Collection,
Promised Gift of Dorothy and Herbert Vogel

Cat. 88 *Structure Poem*, 1968
ink on graph paper
sheet: 11 x 8½ (27.9 x 21.6)
mount: 14½ x 12 (36.8 x 30.5)
The Dorothy and Herbert Vogel Collection,
Promised Gift of Dorothy and Herbert Vogel

Cat. 89 *MANY THINGS PLACED HERE &
THERE TO FORM A PLACE CAPABLE OF
SHELTERING MANY OTHER THINGS PUT
HERE & THERE*, first installation 1980
LANGUAGE + THE MATERIALS
REFERRED TO
size variable
The Dorothy and Herbert Vogel Collection,
Promised Gift of Dorothy and Herbert Vogel

1. Vito Acconci, "Acconci: Notebook Excerpts," *Flash Art* 24 (May 1971), 11.

2. Barbara Rose and Irving Sandler, "Sensibility of the Sixties," *Art in America* 1 (January/February 1967), 49.

3. Barbara Rose, "ABC Art," *Art in America* 5 (October–November 1965), 67.

4. Rose 1965, 68.

5. Maurice Poirier and Jane Necol, comp., "The Sixties in Abstract: Thirteen Statements and an Essay," *Art in America* 9 (October 1983), 137.

6. "The Return of Arthur R. Rose," *Arts Magazine* 6 (February 1989), 46.

7. Lynn Gumpert, Ned Rifkin, and Marcia Tucker, *Early Work: Lynda Benglis, Joan Brown, Luis Jimenez, Gary Stephan, Lawrence Weiner* [exh. cat., The New Museum] (New York, 1982), 10.

8. Bernice Rose, "Thinking is Form: The Drawings of Joseph Beuys," *MoMA Quarterly* 13 (Winter/Spring 1993), 17–18.

9. Mel Bochner, "Excerpts from Speculation [1967–1970]," *Artforum* 9 (May 1970), 71.

10. Mark Rosenthal and Richard Marshall, *Jonathan Borofsky* [exh. cat., Philadelphia Museum of Art] (Philadelphia and New York, 1984), 52.

11. Daniel Buren, "Site Work," *Artforum* 7 (March 1988), 130.

12. Gerd de Vries, ed., *On Art: Artists Writings on the Changed Notion of Art after 1965* (Cologne, 1974), 24.

13. Richard Kostelanetz, ed., *John Cage* (New York, 1970), 1.

14. Barbaralee Diamondstein, *Inside New York's Art World* (New York, 1979), 94.

15. Cindy Nemser, "An Interview with Chuck Close," *Artforum* 5 (January 1970), 51.

16. John Anthony Thwaites, comp., "Eight Artists, Two Generations, Singular Preoccupations," *ARTnews* 8 (October 1978), 71.

17. Lucy Lippard, ed., *Six Years: The Dematerialization of the Art Object from 1966 to 1972* (New York, 1973), 59.

18. Dan Flavin, "Some Remarks . . . Excerpts from a Spleenish Journal," *Artforum* 4 (December 1966), 29.

19. Dan Graham, "Models and Monuments," *Arts Magazine* 5 (March 1967), 34.

20. Cindy Nemser, "An Interview with Eva Hesse," *Artforum* 9 (May 1970), 59.

21. Seth Siegelaub, *January 5–31, 1969* [exh. cat., independent show at 1100 Madison Avenue] (New York, 1969).

22. Rose 1965, 63.

23. Joseph Kosuth, *Non-Anthropomorphic Art by Four Young Artists; Joseph Kosuth, Christine Koslov, Michael Rinaldi, Ernest Rossi; At the Lannis Gallery on 315 E. 12th St. near 2nd Ave. Opening Feb. 19, 12 to 12; Four Statements* [exh. cat., Lannis Gallery] (New York, 196[?]).

24. New York, 196[?].

25. Sol LeWitt, "Paragraphs on Conceptual Art," *Artforum* 10 (Summer 1967), 80.

26. Richard Long, "Richard Long Replies to a Critic," *Art Monthly* 68 (July/August 1983), 20.

27. *Fundamental Painting* [exh. cat., Stedelijk Museum] (Amsterdam, 1975), 37.

28. Sylvia Plimack Mangold, *Inches and Field*, ed. Amy Baker (New York, 1978).

29. Amsterdam 1975, 42.

30. *Richard Nonas: Sculpture/Parts to Anything* [exh. cat., Nassau County Museum of Fine Art] (Roslyn Harbor, New York, 1985), 64.

31. *Dennis Oppenheim: Retrospective— Works 1967–1977* [exh. cat., Musée d'Art Contemporain] (Montreal, 1978), 16.

32. Judy K. Collischan Van Wagner, *Lines of Vision: Drawings by Contemporary Women* (New York, 1989), 116.

33. George Jappe, "Klaus Rinke: Interview," *Studio International* 982 (July/August 1976), 64.

34. "Artists Talk," *Flash Art News* 146 (May–June 1989), 7.

35. Ira G. Wool, "Homage to Dieter: A Rot(h)iana of Annotated Anecdotes," in *Dieter Roth* [exh. cat., David Noland Gallery] (New York, 1989), 13.

36. David Bourdon, "A Heap of Words About Ed Ruscha," *Art International* 9 (November 20, 1971), 25, quoting Christopher Fox, "Talking to Edward Ruscha," [brochure for "News, Mews, Pews, Brews, Stews & Dues"] (London, 1970).

37. Howardina Pindell, "Words with Ruscha," *Print Collector's Newsletter* 6 (January–February 1973), 126.

38. Diamondstein 1979, 333.

39. Joel Shapiro, "Commentaries" in *Joel Shapiro* [exh. cat., Whitney Museum of American Art] (New York, 1982), 97.

40. Robert Smithson, "Cultural Confinement," *Artforum* 2 (October 1972), 39.

41. Willoughby Sharp, "Lawrence Weiner at Amsterdam," Liza Bear, ed., *Avalanche* 4 (Spring 1972), 70.

1975

Selections from the Collection of Dorothy and Herbert Vogel, The Clocktower, The Institute for Art and Urban Resources, New York, 19 April–17 May (Part I of "Collectors of the Seventies: A Series of Presentations about Collectors of Contemporary Art.")

Painting, Drawing and Sculpture of the '60s and the '70s from the Dorothy and Herbert Vogel Collection, Institute of Contemporary Art, University of Pennsylvania, Philadelphia, 7 October–18 November 1975; The Contemporary Arts Center, Cincinnati, 17 December 1975–15 February 1976.

1977

Works from the Collection of Dorothy and Herbert Vogel, The University of Michigan Museum of Art, Ann Arbor, 11 November 1977–1 January 1978.

1981

4 x 7 Selections from the Vogel Collection, Ben Shahn Gallery, William Paterson College, Wayne, 10 October–11 November.

1982

20th Anniversary Exhibition of the Vogel Collection, Brainert Art Gallery, State University College of Arts and Science, Potsdam, 1 October–1 December 1982; Gallery of Art, University of Northern Iowa, Cedar Falls, 5 April–5 May 1983.

1986

Drawings from the Collection of Dorothy and Herbert Vogel, Department Art Galleries, The University of Arkansas at Little Rock, 7 September–16 November 1986; The University of Alabama Moody Gallery of Art, University, 2 February–27 February 1987; The Pennsylvania State University Museum of Art, University Park, 15 March–10 May 1987.

1987

Beyond the Picture: Works by Robert Barry, Sol LeWitt, Robert Mangold, Richard Tuttle from the Collection, Dorothy & Herbert Vogel, New York, Kunsthalle Bielefeld, 3 May–7 July 1987.

1988

From the Collection of Dorothy and Herbert Vogel, Arnot Art Museum, Elmira, 15 October–31 December 1988; Grand Rapids Art Museum, 27 January–19 March 1989; Terra Museum of American Art, Chicago, 8 April–4 June 1989; Laumeier Sculpture Park, St. Louis, 18 June–13 August 1989; Art Museum at Florida State University, Miami, 15 September–10 November 1989.

1992

The Poetry of Form: Richard Tuttle Drawings from the Vogel Collection, Instituto Valenciano de Arte Moderno, 25 June–30 August 1992; Indianapolis Museum of Art, 2 October–21 November 1993.

LIST OF ARTISTS IN THE EXHIBITION

Vito Acconci

Carl Andre

Richard Artschwager

Jo Baer

John Baldessari

Robert Barry

Jennifer Bartlett

Bernd and Hilla Becher

Lynda Benglis

Joseph Beuys

James Bishop

Mel Bochner

Jonathan Borofsky

Daniel Buren

André Cadere

John Cage

Christo

Chuck Close

Merce Cunningham

Hanne Darboven

Jan Dibbets

Dan Flavin

Dan Graham

Robert Grosvenor

Eva Hesse

Douglas Huebler

Donald Judd

On Kawara

Joseph Kosuth

Sol LeWitt

Richard Long

Robert Mangold

Sylvia Plimack Mangold

Brice Marden

Robert Morris

Richard Nonas

Dennis Oppenheim

Nam June Paik

Edda Renouf

Klaus Rinke

Dorothea Rockburne

Dieter Roth

Edward Ruscha

Robert Ryman

Alan Saret

Joel Shapiro

Robert Smithson

Richard Tuttle

Lawrence Weiner

143

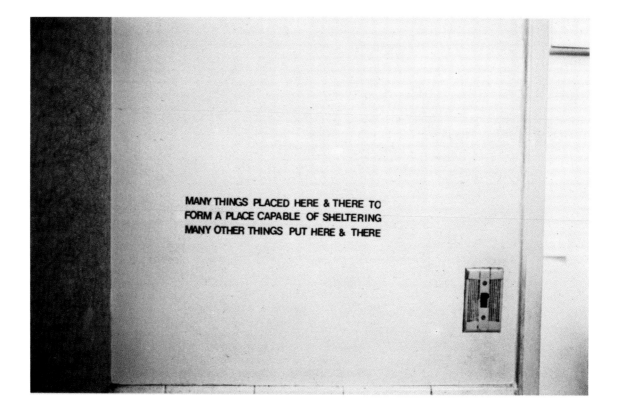

SELECTED BIBLIOGRAPHY
Writings about the Vogels

Barnett, Catherine. "A Package Deal." *Art and Antiques* 6 (Summer 1986): 39–41.

Cox, Meg. "Postal Clerk and Wife Amass Art Collection in a New York Flat." *Wall Street Journal* (30 January 1986): 1, 20.

D'Arcy, David. "The Unlikely Medici." *Los Angeles Times* (16 January 1992): F1, F8, F9.

Gardner, Paul. "Look! It's the Vogels!" *ARTnews* 3 (March 1979): 84–88.

Gardner, Paul. "Mesmerized by Minimalism." *Contemporanea-International Art Magazine* 9 (December 1989): 56–61.

Gardner, Paul. "An Extraordinary Gift of Art from Ordinary People." *Smithsonian* 7 (October 1992): 124–126, 128, 130, 132.

Haden-Guest, Anthony. "A New Art-World Legend: Good-by, Bob and Ethel; Hullo, Dorothy and Herb!" *New York* (28 April 1975): 46–48.

Hemphill, Chris. "The Vogels: Minimal Collectors." *Interview* 5 (May 1974): 19.

Lewis, Jo Ann. "National Gallery's Cache Advantage: Vogels Promise Vanguard Collection." *The Washington Post* (8 January 1992): C1, C3.

Mandell, Jonathan. "Maximum Minimalism." *New York Newsday: Part II* (23 January 1992): 60, 61, 89.

Rimer, Sara. "Collecting Priceless Art, Just for the Love of It." *The New York Times* (11 February 1992): A1, B4.

Ryan, Michael. "Trust Your Eye." *Parade Magazine* (12 April 1992), 10–11.

Shapiro, Harriet. "Using Modest Means, the Vogels Build a Major Collection." *People* (8 September 1986): 59–65.

Simmons, Kenna. "The Collective Eye." *Horizon* 8 (October 1988): 14–16.

Vogel, Carol. "National is Pledged Two-Thousand-Work Collection." *The New York Times* (8 January 1992): C13.